Buyer's Price Guide

ART NOUVEAU

Compiled and Edited

by

Stuart M. Brunger, B.A.

Consultant Editor

Judith H. Miller, M.A.

mJm
PUBLICATIONS
Pugin's Hall
Finchden Manor
Tenterden
Kent
telephone 058 06 2234

The Publishers would like to acknowledge the
great assistance given by:

Aldridges, 130-132 Walcot Street,
Bath, Avon.

Anderson and Garland, Market
Street, Newcastle-upon-Tyne
NE1 6XA.

Bonhams, Montpelier Street,
London, S.W.7.

Christie, Manson & Woods Ltd.,
8 King Street, London
SW1Y 6QT.

Christie, Manson & Woods
International Inc., 502 Park
Avenue, New York 10022.

Christie's East, 219 East 67th
Street, New York 10021.

Christie's (International) S.A.,
8 Place de la Taconnerie,
1204 Geneva.

Christie's South Kensington,
85 Old Brompton Road,
London, S.W.7.

Dacre Son and Hartley,
1-5 The Grove, Ilkley, Yorkshire.

Fabrique, 208 Clarendon Park
Road, Leicester.

Geering & Colyer, Hawkhurst,
Kent.

Henry Spencer & Sons,
20 The Square, Retford, Notts.

Hy. Duke & Son, 40 South Street,
Dorchester, Dorset.

John Hogbin & Son, 53 High Street,
Tenterden.

K. Norton Grant, Stand 176,
Grays Antique Market,
58 Davies Street, London, W.1.

Langlois, 10 Waterloo Street,
Jersey, C.I.

Leicester Antiques Centre Ltd.,
16-26 Oxford Street, Leicester.

L'Exposition (Marilyn Mellins),
Stand C29/32, Grays in the Mews,
Davies Mews, London, W.1.

Louis Taylor & Sons, Percy Street,
Hanley, Stoke-on-Trent.

Morphets of Harrogate, The Mart,
4 & 6 Albert Street, Harrogate,
Yorks.

Neales of Nottingham,
192 Mansfield Road,
Nottingham.

Peter Wilson, Market Street,
Nantwich, Cheshire.

Phillips Auctioneers, Blenstock
House, 7 Blenheim Street,
London W1Y 0AS.

Robert McTear & Co., Royal
Exchange Salerooms, 6 North
Court, St. Vincent Place,
Glasgow.

Sotheby Bearne, Rainbow,
Torquay TQ2 5TG.

Sotheby Belgravia, 19 Motcomb
Street, London SW1X 8LB.

Sotheby Beresford Adams, Booth
Mansion, 28 Watergate Street,
Chester CH1 1NP.

Sotheby King & Chasemore,
Station Road, Pulborough,
West Sussex RH20 1AJ.

Sotheby, Parke Bernet and Co.,
34-35 New Bond Street, London
W1A 2AA.

Sotheby Park Bernet Monaco S.A.,
P.O. Box 45, Sporting d'Hiver,
Place du Casino, Monaco.

Made and Printed in Great Britain by
Robert MacLehose, Scotland

CONTENTS

Since individual artists and designers had such a major influence on the various Art Nouveau styles, the more important sections in this book have been categorised in the first instance according to personality as opposed to item. Hence furniture, for example, runs alphabetically from 'Bugatti' to 'Wylie and Lockhead' instead of running from 'Beds' to 'Whatnots'.

Introduction

During the second half of the nineteenth century, European artists and intellectuals were growing increasingly discontented with the accepted principle that the greatest of man's artistic achievements were rooted in the classical past. There were several instances of revolt — notably the emergence of Impressionism in the Paris of the 1870's, and of the Pre-Raphaelite Brotherhood in England. While the impressionists were solely concerned with painting, the Pre-Raphaelites were equally concerned with the quality of every aspect of life. Ruskin, the English art critic and social theorist, was promoting the then heretical idea that man is ennobled by labour, and that his finest products should bear the marks of his labour. He deplored the smooth, machine-like finish demanded by the sophisticated taste of the time, and his disciple, William Morris, translated his theories into practice with the formation of the Arts and Crafts movement.

SOURCES OF INSPIRATION

Nature, not classical precedent, was felt to be the true wellspring of honest creative endeavour, and it was the craftsman, not the effete designer remote from his materials, whom nature would inspire to create objects of 'honest' beauty. Morris' philosophy, which was founded on a romantic (and totally unrealistic) view of mediaevalism as expressed in the Arthurian legend, saw the machine as entirely inimical to this ideal. Nevertheless, he and others like him were breaching the walls of tradition and paving the way for a new art; an art which would have nothing to do with privilege and wealth, or with museums and galleries; an art which would touch every aspect of life through its expression in everyday objects.

The return to nature as a source of inspiration had been largely a consequence of the introduction to the western world of Japanese art, notably at the World Exhibition held in London in 1862. In France the influence was no less strong, though it arrived a few years later. Western artists were fascinated by the abstraction of natural forms, and by the expression of the unity of all nature which this allowed. The theme of the woman-flower was one that, more than any other, would later be universally regarded as the hallmark of the new art.

TWO SCHOOLS

Although the new gospel spread throughout Western Europe and America, the interpretation of its message was by no means uniform. Each artist or group of artists sought individual means of expression, and a wide variety of styles emerged. Although there are many 'grey areas', it is possible to divide Art Nouveau into two broad categories; the ascetic school, as typified by Rennie Mackintosh, and the sensuous school of which Gallé was one of the chief exponents. Somewhere between the two we find the popular, pseudo-mediaeval styles, whose production was encouraged by Arthur Lazenby Liberty for sale in his London, and later Parisian, shops.

Looked at in a historical context, it becomes evident that the direction taken by the French designers was a dead end. Although their creations were, in the main, beautifully made — and have since provided inspiration for a few modern designers — the First World War rendered them irrelevant and the movement ceased abruptly there and then. The other branch, however, continued to bear fruit, paving the way for the modernist school, the Bauhaus and much that

is best in architecture and design of the present day.

Since the 1960's, Art Nouveau has found increasing favour with collectors — and prices have risen accordingly. Nevertheless, there is a wealth of material on the market, much of which is well within the pocket of even the quite modest collector. Of course, signed original pieces by the great names of the movement are rarely seen outside museums and the most important collections, but, even today, local auction houses turn up good quality furniture, glass, ceramics, metalware and jewellery at prices which are comparatively modest and still represent good value for money.

PRICES

The pieces illustrated throughout this book have been selected to represent a broad cross section of the products of the Art Nouveau movement which are likely to be found on the market today. All the price ranges have been arrived at in consultation with a number of respected professional dealers and auction house valuers, and, as such, constitute realistic guide-lines as to the prices currently obtained.

It cannot be too strongly stressed that condition is of the utmost importance in the consideration of any price. This is particularly so in the case of Art Nouveau. Because the Art Nouveau period was rela-tively recent — it may reasonably be said to have ended by 1918, though a number of manufacturers continued to produce the more popular lines after that date — a great many pieces are to be found in absolutely perfect condition. Many, too, were produced in considerable quantity, and it would be unrea-sonable to expect a piece bearing even slight damage to realise as much as an identical, but perfect, specimen. Unless otherwise stated, all price ranges herein may be taken as representing the current market values of pieces in good showroom condition.

In the main, the pieces selected for inclusion in this book represent some of the best and most definitive examples of the 'high' Art Nouveau style as created by the movement's

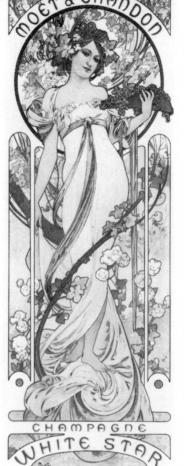

'Moët & Chandon — White Star' by Alphonse Mucha, a chromolitho-graphic poster, printed in fresh colours and gilt, issued in 1899 and printed by F. Champenois, Paris, image area 58 by 19.5 cm., signed in block and dated '99, framed and glazed. **£600-800**

acknowledged leaders. By this means, it is hoped to provide the reader with a yardstick, against which all other Art Nouveau pieces may be measured.

FURNITURE

Perhaps in no other area than furniture is the divergence of paths taken by Art Nouveau designers so evident. Prior to the late nineteenth century, furniture design had been closely related to architectural design, often employing the lines, proportions and decorative devices of the great buildings of the Greek and Roman empires. Exponents of the new art, turning their backs on classical precedent, introduced an entirely new sculptural element into their furniture.

While all Art Nouveau is based upon themes drawn from nature, the French and Southern European designers tended to accentuate the swirls and sensuous curves which are the external, visible characteristics of natural growth, while the Scottish and other Northern European schools sought a more abstract, and usually austere, form of expression, suggesting rather than describing their theme. The latter groups often worked in oak, while the opulence of the more flamboyant Continental styles was generally captured in more decorative — and sometimes quite exotic — timbers. Not uncommonly, metals, ceramics, leather and even parchment were used for decorative embellishment in addition to the more traditional inlays of ivory and contrasting wood veneers.

Not all furniture is representative of the 'high' Art Nouveau styles, and much that is totally in keeping with today's taste, can be bought at prices which are not unreasonable considering the consistently high standards of workmanship and materials which characterise them.

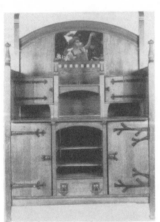

An oak buffet by Henri-Jules-Ferdinand Bellery-Desfontaines, with a painted panel of fin-de-siècle maiden harvesting fruit, with black-painted heavily hammered wrought-iron key plates and hinges, the sides with additional doors, 84½ in. high, 59 in. wide, c. 1900. **£800-1,000**
A student of Jean-Paul Laurens, Bellery-Desfontaines was an accomplished painter who exhibited annually in the 1890's at the Champs Elysées. From 1897 he began to apply himself to furniture design.

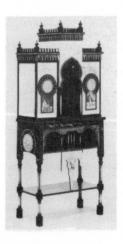

A good inlaid and painted Bugatti cabinet, ebony framework inlaid in pewter with plant motifs and the geometric inlays in pewter, ivory and wrought copper, the painted vellum panels with Arab figure and plant subjects, 194 cm. height, 88 cm. width, 39 cm. depth, the painted decoration signed 'Tilligrini' (?), c. 1900. **£2,000-2,500**

BUGATTI, Carlo
(1855-1940)

Father of Ettore, the car designer, and Rembrandt, a sculptor of animals, Carlo Bugatti was one of the great individualists and innovators of his time. Born in Milan, the son of an architectural carver, he trained as an architect before entering the field of furniture design.

His eccentric designs, with their incrustations of ivory, metals and parchment reveal a Moorish — almost Arabian nights — influence in addition to the Japanese influence which is traditionally associated with Art Nouveau. For the last thirty years of his life he lived in Pierrefonds, France, devoting himself mainly to painting, though he did produce some commissioned designs for silverware — and served for a time as Mayor.

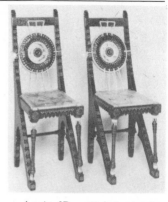

A pair of Bugatti chairs, inset with metal motifs, the seats and backs covered in vellum painted with birds and stylised flowers, 92.25 cm., 1880. **£1,000-1,500**

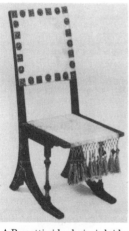

A Bugatti side chair, inlaid with pewter, the vellum covered back applied with panels of beaten copper, seat with silk fringes, 95 cm. height, c. 1900. **£450-600**

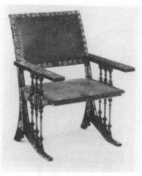

A large Bugatti throne, inlaid with pewter and applied with beaten copper, the seat covered in black leather, the back re-upholstered, 93.5 cm. height, c. 1900. **£400-600**

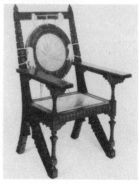

A Bugatti armchair, inlaid with pewter, the crest-rail covered in repoussé copper, the vellum-covered back painted with a marijuana leaf within a repoussé copper border; the seat similarly decorated, 47 in. high, some inlay missing. **£750-1,000**

11

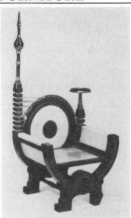

A Bugatti throne chair, the wooden framework covered in vellum and bands of wrought and pierced copper, inlaid in brass and pewter, 149 cm., c. 1900. **£300-500**

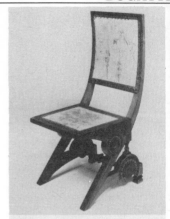

A walnut chair by Carlo Bugatti, inlaid with pewter, upholstered in vellum and overpainted with Japanese-style plants and birds, the seat similarly decorated within beaten coppered-brass border, the back with painted Bugatti signature, restoration to seat rails. **£500-700**

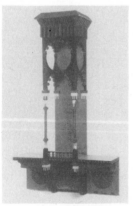

An ebonised and mahogany hanging shelf by Carlo Bugatti, inlaid in ivory with stars, the vellum covered back mounted with a pierced copper plaque and supported on a beaten copper bracket, 101 cm. high. **£400-600**

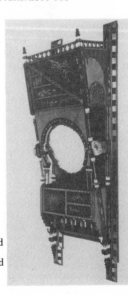

A Carlo Bugatti hanging cupboard, the central mirror having two small drawers and an open compartment below and four drawers above, heavily decorated with ivory, copper and other metals, 126 cm. high, c. 1880. **£1,200-1,600**

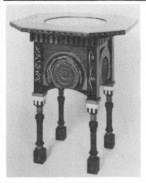

A small octagonal table by Carlo Bugatti, inset with parchment, decorated with a hammered copper sunset and stylised birds and flowers, 65 cm. high, c. 1880. **£1,500-2,000**

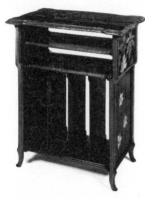

A fine inlaid mahogany music canterbury, by Emile Gallé, the top inlaid in sycamore oak and walnut with flowering narcissi in a landscape, the sides also inlaid, signed in marquetry Gallé, height 34½ in., width 30 in. **£1,500-2,000**

GALLÉ, Emile
(1846-1904)

If not the father, certainly one of the foremost figures of the French Art Nouveau movement, Emile Gallé was the founder of the Nancy school. After a liberal education, he began his working life as apprentice to his father, a studio glassmaker. The development of his unique Art Nouveau style is considered to have dated from about 1884, and within six years he was running a factory supplying large quantities of studio glass to, among others, the Parisian shop of Sebastian Bing, the international entrepreneur. The shop was called l'Art Nouveau.

Gallé was widely imitated by other glass workers, but few, if any, could match his technical skill or artistic feeling. In 1880 he began to produce Art Nouveau furniture of extremely high quality, often embellishing his products with inlays — notably mother of pearl — and characteristically delicate marquetry designs.

Following his death in 1904, articles produced by his factories continued to be signed 'Gallé', but all were marked with a star from that time onward.

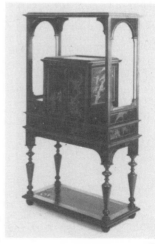

A Gallé marquetry cabinet, veneered and carved in shallow relief with painted and stained chrysanthemums and dandelion leaves, 80 cm., signed L'ébéniste Emile Gallé, Nancy. **£1,000-£2,000**

13

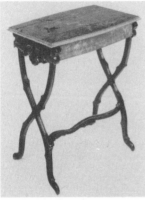

An inlaid mahogany petite coiffeuse, by Emile Gallé, the top and frieze drawer inlaid with fuchsia, with marquetry signature, 29 in. high, 23½ in. wide, 15½ in. deep. **£1,500-2,000**

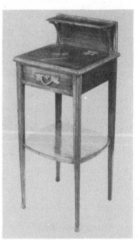

A small mahogany commode de chevet, by Emile Gallé, the rectangular top inlaid in various fruit woods with flowering poppies and buds, the two doors similarly inlaid, signed in the inlay, 23⅝ in. high, 21 in. wide. **£950-1,250**

An unusual carved and painted cabinet, painted in tones of amber, brown and yellow with autumnal flowers and leaves, signed Emile Gallé, Nancy, 43¼ in. high. **£1,000-1,200**

An oak and marquetry lady's writing desk, by Emile Gallé, the top with panels of walnut and mahogany, inlaid with a design of narcissi in beech, sycamore and harewood, 95 cm. high, signed 'Gallé'. **£500-700**

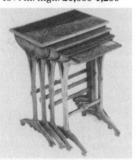

An inlaid mahogany nest of tables, by Emile Gallé, each with moulded tops inlaid in burl maple, oak, and with bois clair veneers, all with marquetry signature, 28½ in. high. **£1,500-2,000**

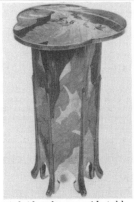

An inlaid mahogany 3-tier étagère, by Emile Gallé, inlaid in rosewood and oak, with bois clair veneers, 49½ in. high. **£2,250-2,500**

An inlaid mahogany side table by Emile Gallé, inlaid with orchids, the base of closed hexagonal form with abstract inlaid designs, marquetry signature, 28¼ in. high, 19 in. diam. **£1,500-2,000**

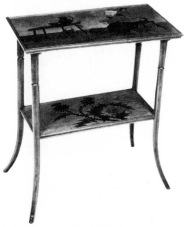

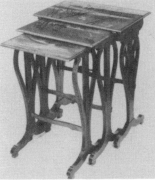

A nest of three Gallé marquetry tables, each inlaid with sycamore, partridge wood, burr-elm and maple, 68 cm., high, each signed 'Gallé'. **£600-800**

An inlaid mahogany 2-tier tea table, by Emile Gallé, the top inlaid in purple heart, oak and various fruitwoods with an old woman and two cats seated in front of a bucket, coal skuttle and table with milk jug, with early branded signature, 30 in. high, 27¼ in. wide. **£800-1,200**

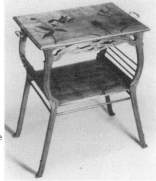

A 2-tier marquetry tea table, the tray top with two bronze handles, inlaid in various fruitwoods, signed Gallé on a leaf. **£800-1,000**

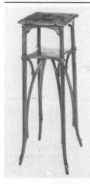

An inlaid mahogany 2-tier sellette, by Emile Gallé, the top veneered in purple heart, oak and stained fruitwoods with autumn leaves; the undertier similarly inlaid, marquetry signature, 44½ in. high, 16 in. square. **£1,000-1,500**

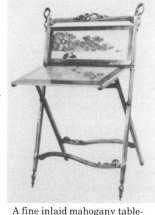

A fine inlaid mahogany table-pliante, by Emile Gallé, inlaid with clematis boughs in blossom, branded signature, 42½ in. high, 28¾ in. wide, 21¾ in. deep. **£1,600-2,200**

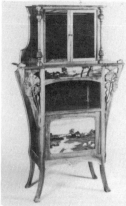

A fine inlaid mahogany vitrine, by Emile Gallé, veneered in fruitwoods, signed in marquetry Gallé, 38½ in. wide, 65¼ in. high, c. 1900. **£4,000-5,500**

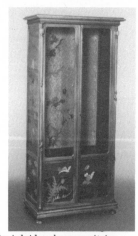

An inlaid mahogany vitrine, finely inlaid with flowering poppies and leaves, the sides inlaid with dahlias above a smaller panel of poppy flowers and buds, signed Gallé Nancy on a leaf, 76 in. high. **£4,800-5,600**

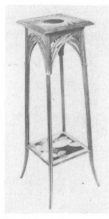

An inlaid mahogany 2-tier sellette, by Emile Gallé, the top veneered in stained fruitwoods with a palm frond encircling a central medallion, the undertier inlaid in burled woods with a cactus plant on a purple heart ground, with marquetry signature, 44½ in. high. **£2,000-£2,500**

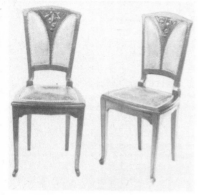

A set of 6 mahogany dining chairs, by Jacques Gruber, all with shield-shaped backs carved with a spray of foliage separating twin studded and padded backrests, upholstered in tan leather, 37 in. high. **£2,000-2,300** *Along with Emile Gallé, Louis Majorelle and Eugene Vallin, Jacques Gruber was one of the most important designers to come from Nancy.*

A mahogany extension dining table, by Jacques Gruber, 51 in. long unextended. **£1,800-2,200**

An oak armchair, designed by Charles Rennie Mackintosh for the Argyle Street Tea Rooms, with original horse-hair seat, 96.75 cm. high, 1897. **£2,200-£2,700**

MAJORELLE, Louis (1859-1926)

Following his father's death in 1879, Majorelle took over the family furniture business in Nancy, making reproductions of eighteenth century designs. Some ten years later, recognising the commercial possibilities of the Art Nouveau style, he began to reorganise his workshops and catalogues and, by 1900, he had become France's leading manufacturer of Art Nouveau furniture.

Although the spirit of Art Nouveau was opposed to machine made products, Majorelle mechanised his workshops, enabling him to produce highly fashionable furniture at prices which brought it within the reach of a reasonably wide market.

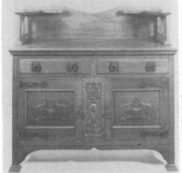

An Art Nouveau Liberty-style oak sideboard, the rectangular top with attached splashboard, the doors inlaid with marquetry. **£250-350**

17

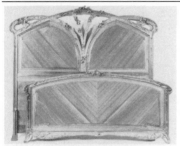

A mahogany double bed, by L. Majorelle, in a pattern similar to Clématite, 62½ in. high, 71½ in. wide. **£3,000-4,500**

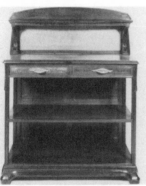

A mahogany sideboard in the 'Blé' pattern, by Louis Majorelle, the arched cornice above a bevelled glass panel, with foliate ormolu handles and key escutcheons, 56 x 48 in. **£1,100-£1,300**

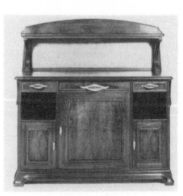

An Art Nouveau pale walnut buffet, attributed to Louis Majorelle, with glazed door flanked by two small drawers above three shelves, 180 cm. high. **£3,000-4,000**

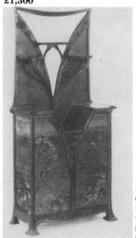

A mahogany buffet in the 'Blé' pattern, by Louis Majorelle, the three frieze drawers raised on a cupboard, open shelf space and two smaller cupboards, 61 x 63 in. **£1,200-1,400**

A carved and marquetry inlaid cabinet, by Louis Majorelle, the mirrored back above a cupboard with two doors, 200 cm. high, signed 'L. Majorelle', c. 1900. **£5,000-7,000**

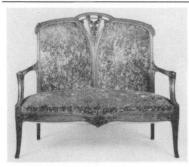

An Art Nouveau walnut canapé, attributed to Louis Majorelle, covered in contemporary golden plush, 136 cm. wide. **£1,750-£2,250**

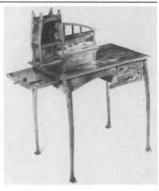

An Art Nouveau inlaid lady's desk with bookrack, in the style of Louis Majorelle, inlaid design of ducks in a pastoral landscape and a deer hunt, 29 in. high, 32½ in. long, 20 in. deep. **£450-£600**

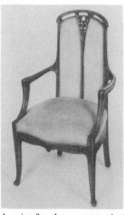

A pair of mahogany armchairs, by L. Majorelle, in the Clématite pattern finely carved with clematis, upholstered in beige velvet, 40½ in. high, 24½ in. wide. **£1,500-2,000**

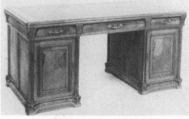

A mahogany pedestal desk, by L. Majorelle, in the 'Algues' pattern, the cupboard doors reveal 4 sliding drawers, the sides with matchbook veneers, signed, 29½ in. high, 63 in. wide, 31½ in. deep. **£1,500-2,200**

Remember that this book is a price *guide,* not a price *list.* Valuations given throughout apply to the specific prices shown and, though they may reasonably be taken as a guide to the values of other similar articles, other factors may also apply.

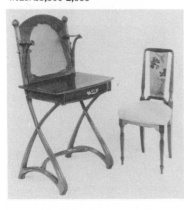

A mahogany coiffeuse and chair, by Louis Majorelle, the legs of organic trestle form to support the top, the frieze drawer with gilt bronze pull, unsigned, 49¾ in. high, 28¼ in. wide, 18¾ in. deep; the chair with central splat inlaid with orchids, unsigned, 37 in. high. **£2,000-£3,000**

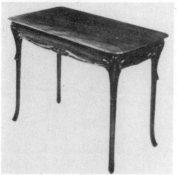

A French Art Nouveau mahogany table, designed in the manner of Majorelle, 107 cm. across. **£500-600**

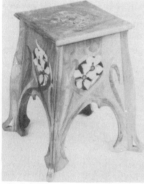

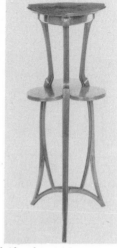

An inlaid mahogany 2-tier sellette, by L. Majorelle, inlaid with maple leaves and pods, marquetry signature, 47 in. high, 18½ in. wide. **£1,250-2,000**

An inlaid mahogany table, by L. Majorelle, of organic form, the sides pierced and inlaid to depict jonquils in bloom, branded signature, 19¼ in. high, 16 in. wide. **£900-1,200**

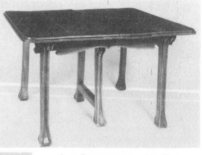

A mahogany extension dining room table, by Louis Majorelle, the moulded top on fluted feet continuing to pad feet centering a gate-leg support, with six extension leaves, 50 by 45 in. unextended. **£2,200-3,000**

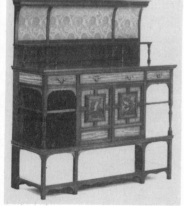

A mahogany and satinwood sideboard, probably made by William Morris & Co., the shallow overhanging cornice applied with damask, the two panelled cupboard doors inset with pressed and painted canvas panels of angels, 65¼ by 63¼ in., 1900-10. **£350-550**

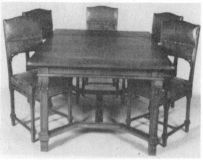

An Art Nouveau mahogany
dining table, with eight
matching chairs, probably by
George Moser, Austrian, the
table, 58 in. long, the chairs with
rectangular back, upholstered in
brown leather and fitted with
brass clinches, 38 in. high.
£1,200-1,250

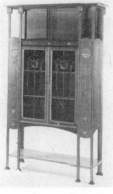

A sycamore vitrine cabinet, in
the style of Wylie and Lockhead,
the leaded glass cupboard doors
with pink rose motifs, the frieze
inlaid in mother of pearl with
hearts, the sides with stylised
plants, inlaid with lilac stained
and abalone panels, 118 cm.
wide. **£1,200-1,600**

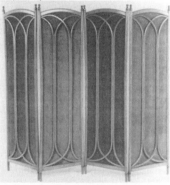

A fine 4-leaf bentwood screen in
the 'Spanish Wall' pattern, by
Thonet, each panel with Gothic
Arch struts backed by a plush
olive-green velveteen fabric,
70 in. high, width 82 in., c. 1900.
£1,500-1,750

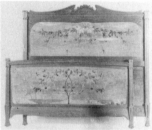

A French inlaid mahogany
double bed, the headboard inlaid
in pearwood, purple heart, and
various fruitwoods with grape-
laden vines against a cloudy sky;
the footboard similarly inlaid
with an overhanging raspberry
spray with thistles and leaves,
54 in., height of headboard,
80 in. long, c. 1900. **£400-600**

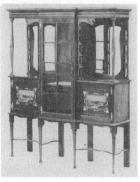

An Art Nouveau mahogany
display cabinet, with a single
glazed cupboard door flanked by
open shelves with mirrored
backs, painted with a blossoming
tree and flowing ribbon work,
the lower part with two cupboard
doors inlaid with a lakeside
scene, 72½ by 56 in., c. 1900.
£500-800

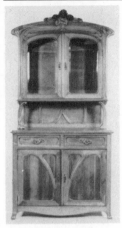

An Art Nouveau mahogany
buffet, the cornice carved with
central hydrangea blossoms,
with foliate ormolu bail handles
and key escutcheons, French,
c. 1900, 92 by 47 in. **£750-1,000**

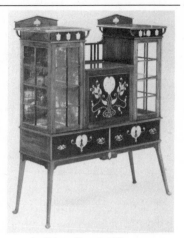

An Edwardian Art Nouveau
'Quaint' display cabinet, the
central fall-front flanked by two
display cabinets with glazed
doors at the side, the whole
inlaid with foliage, 58½ by 52 in.,
bearing a label Christ, Pratt &
Sons, Cabinet Makers and
Upholsterers, Carpet and
Bedding Warehousemen,
Bradford, 1900-10. **£300-500**
*Note the use of foliage decoration
characteristic of 'Quaint'
furniture. For a discussion on
'Quaint' furniture see 'British
Furniture 1880-1915' by Pauline
Agius.*

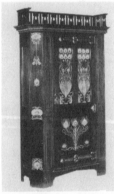

An Art Nouveau mahogany and
marquetry cupboard, with a
single panelled cupboard door
inlaid in green stained woods,
mounted with copper handle and
hinges, 132 cm. wide. **£1,000-
£1,500**

Make the most of Millers . . .

Remember that this book is a
price *guide,* not a price *list.*
Valuations given throughout
apply to the specific prices
shown and, though they may
reasonably be taken as a guide
to the values of other similar
articles, other factors may
also apply.

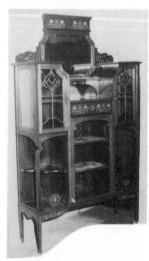

An Art Nouveau display cabinet,
48 in. wide, 78 in. high. **£400-450**

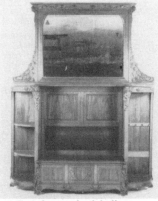

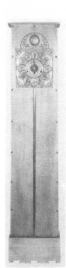

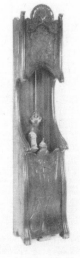

A French carved oak hallway
furniture piece, the upper part
with a bevelled mirror within a
flaring mount above a central
hall bench, the seat opening to
storage space, flanked by shelves
and an umbrella stand, all
carved with hydrangea, 85 in.
wide, 104.5 in. high, c. 1900.
£1,250-1,500

An Art Nouveau longcase clock
by Loaduc Rappe, the oak case
with multi-coloured enamelled
sunburst dial with bronze corner
motifs, surmounted by a disc
depicting a Mucha style girl, the
case edged with crimson
enamelled discs and overlaid
with a central brass rod, German
movement, quarter-striking on 2
gongs, signed in the bronze and
initials LR on disc, 191.5 cm.
high. **£200-300**

An Art Nouveau oak longcase
clock, the gilt-metal dial cast
with a stork amongst cat-tails,
the oak case carved with lotus
leaves and interlaced stems,
French, c. 1900, 88 in. high.
£2,000-3,000

An Art Nouveau mahogany hall
umbrella stand/coat rack,
with curved brass umbrella rail,
85¼ in. high, 46½ in. wide.
£900-1,250

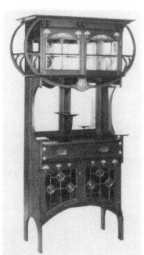

An Art Nouveau mahogany
display cabinet, inlaid with
panels of stylised flowers,
103 cm. wide. **£660-800**

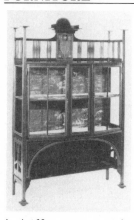

An Art Nouveau green-stained beech display cabinet, the three-quartered galleried bowed top centred by a stylised floral panel inlaid with mother of pearl, 46½ in. wide. **£900-1,200**

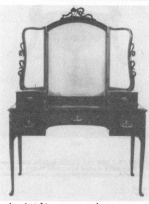

An Art Nouveau mahogany dressing table, the shaped rectangular top above a short central drawer flanked by 2 side drawers, on 4 cabriole legs ending in pad feet, all with stylised hardware, 66 in. high, 46 in. long, 23in. wide. **£300-400**

*The pieces of furniture illustrated on this page indicate the diversity of styles that are to be found under the general heading of Art Nouveau. The display cabinet — **above left** — is very much in the 'Northern' tradition, with austere lines which are relieved by fret-cut decorative panels in the lower sides and the Celtic design of the central panel above. The walnut chairs — **below** — on the other hand, display hardly any straight lines at all; every member flowing organically into the next. Notice the tribute to the mediaeval ideal in the Gothic arch of the backs. The mahogany dressing table — **above right** — pays mere lip-service to the Art Nouveau movement through the flaccid curves of the outside mirrors and the fragmentary — and quite unconnected — decoration on mirror frames and drawer handles.*

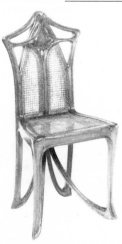

Four walnut Art Nouveau chairs, 36½ in. high. **£800-£1,200**

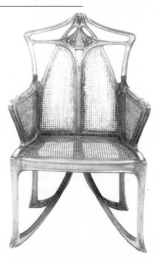

A pair of walnut armchairs, 39 in. high. **£700-1,000**

CERAMICS

In general, the Art Nouveau movement unleashed a flood of studio pottery of mediocre quality. There were, nevertheless, a number of studios and individual craftsmen who produced outstanding work and made great technical advances in order to give substance to their artistic vision. Notable among these was Ernest Chaplet (1835-1909) who developed a succession of unique coloured glazes, the secrets of which he burned before his death. Of the English potters, William Howson Taylor earned international acclaim for the oriental-inspired wares from his Ruskin Pottery at Smethwick.

A Boucheron stamped stoneware jug, the creamy glaze speckled with blue, underside marked 'Boucheron Paris London', 27 cm., c. 1900. **£500-550**

A gilt and polychromed pottery basket, by Emile Gallé, Nancy, decorated in the Egyptian taste, painted in purple, blue and black, highlighted with gilding, all on white high glazed ground, signed Emile Gallé, Nancy, and moulded Gallé, Nancy déposé, monogrammed with Fecit and moulded swan having snake body, repairs on handle, 10 in. high, c. 1900. **£200-300**

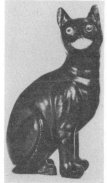

A faience cat, by Emile Gallé, in matt black with white encircling the mouth, the applied green glass eyes with black pupils, signed E. Gallé, 13½ in. high. **£800-1,200**

A pair of Gallé faience cats, painted with sprigs of flowers in naturalistic colours against a pink ground, 34.5 cm., enamelled mark 'E. Gallé Nancy', 1880's. **£1,200-1,500**

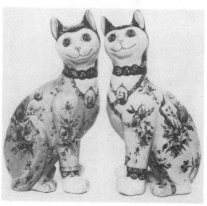

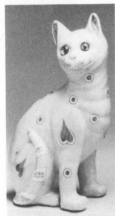

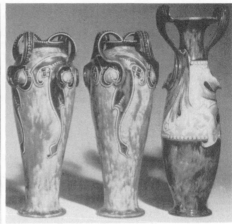

A pottery seated cat, painted in bright yellow with blue hearts and circular motifs, the applied glass eyes with black pupils, signed E. Gallé, Nancy, 33 cm. high. **£1,000-1,200**

A pair of Royal Doulton stoneware vases, by Frank A. Butler, impressed crowned Royal Doulton England mark, c. 1905, 36.5 cm. high. **£200-260**

Above right
A Royal Doulton stoneware vase, by Frank A. Butler with two foliage scroll handles and pâte-sur-pâte with a band of foliage on a streaked blue and green ground, c. 1905, 41.5 cm. high. **£180-280**

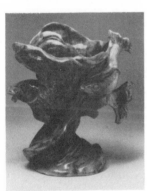

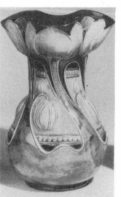

A pottery Nautilus vase, modelled with 3 carps and an infant Triton on a dolphin's back, painted in blue, brown and red, signed Emile Gallé Nancy, 13 in. high. **£1,100-1,500**

A Doulton stoneware pear-shaped vase, by Frank A. Butler, moulded with open lilies and gooseberries, impressed circular Doulton Lambeth, England mark, c. 1905, 26 cm. high. **£90-120**

A Royal Doulton stoneware vase, decorated by Mark V. Marshall, with symmetrical panels of exotic birds in blue, green and brown glazes, impressed lion crown and circle mark, c. 1895, 35 cm. high. **£170-230**

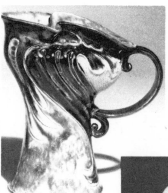

A Doulton stoneware jug, by Frank A. Butler, carved with symmetrical foliage and scrolls, impressed circular Doulton Lambeth, England mark, c. 1905, 18 cm. high. **£80-120**

An unusual Royal Doulton earthenware vase, the red body decorated in white slip beneath a honey glaze, 29 cm. high. **£90-£150**

A Gouda decorated earthenware vase, finely painted with flowers and leaves in purple, orange and green against a cream ground, 31 cm. printed mark 'Zuid Holland' 'Gouda', c. 1900. **£130-£200**

A Goldschieder cold painted earthenware bust of a young woman, moulded factory plaque, impressed 'Reproduction Reserve', numbered '1994 401 34', 63 cm., c. 1900. **£300-370**

An ormolu-mounted porcelain vase, by Charles Korschann, painted green and gold, moulded with Venus and Cupid in relief, the reverse with an Art Nouveau motif incorporating freesias, inscribed CH. KORSCHANN PARIS and impressed with the Louchet foundry seal, French, early 20th C., 26⅝ in. high. **£2,000-3,000**

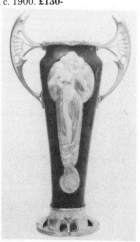

An earthenware handled vase, by Hector Guimard, with 4 ribbed handles and an openwork neck, in a green glaze, unsigned, 11 in. high. **£600-800**
Hector Guimard was an influential French designer who aimed to create complete environments. Whenever he designed a building, the plan incorporated furniture, lock plates, light fittings, and so on. This explains why individual examples of Guimard's work can, when taken out of context, appear absurd or even grotesque.

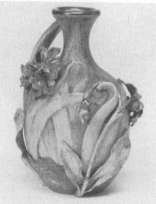

A metal-overlay earthenware handled vase, by Lachenal, the body overlaid with gilt-metal leaves and stems and silver irises, painted LACHENAL, 6 in. high. **£150-250**

MARTIN BROTHERS (Robert, Charles, Walter and Edwin)

Robert Wallace Martin was the first born of the Martin brothers, and it seems to have been he who directed the energies of his brothers into producing the kind of grotesque, neo-gothic stoneware that made their name. The Fulham studio that he set up in 1873 proving too small, the brothers moved to larger premises in Southall four years later. Although they made many similar pieces, no two are identical. The studio ceased production in 1914.

A stoneware vase, by Martin Brothers, 1903, minor flake to glaze on body incised with firm's marks and 10-1903, 10 in. high. **£200-250**

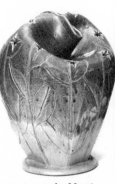

Left
A stoneware vase, by Martin Brothers, London, incised with the firm's marks, 7⅛ in. high. **£180-260**

A stoneware vase, by Martin Brothers, incised with the firm's marks, 8¼ in. high. **£180-260**

A large Clément Massier lustre glazed earthenware jardiniere, 24.5 cm., stamped 'Clément Massier Golfe Juan' c. 1900.
£300-500

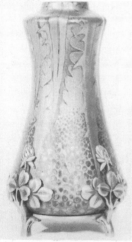

A bronze-mounted pottery vase, with stylised leaves and speckles in rainbow iridescence, the gilt-bronze mount cast with four clover plants, signed and impressed CLEMENT MASSIER GOLFE-JUAN AM, 8 in. high, c. 1900. **£400-500**

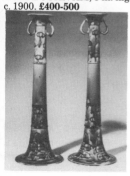

Left
A pair of Minton 'Secessionist' candlesticks, printed Minton Ltd. No. 2, c. 1889, 52 cm. high.
£320-420

The Secession was the Austrian Art Nouveau movement which was dominated by the architect Josef Hoffmann. The majority of their designs were 'modernist' and influenced by the Art Nouveau of the Glasgow School.

An ormolu mounted pottery vase, by Clément Massier, painted in yellow, green and violet lustres with giant dragonflies, impressed Clément Massier Golfe Juan (A.M.) and painted in lustre MCM Golfe Juan (AM), 1900, 13 in. high.
£1,800-2,200

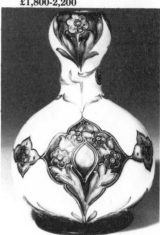

An unusual Moorcroft Macintyre 'Florian Ware' vase, decorated with barbed panels of blue flowers with olive leaves, reserved against a white ground, 17.50 cm. high, Macintyre marks and 'W. Moorcroft' in green.
£220-320

29

CERAMICS

A silver-overlay earthenware mug, by Rookwood, 1905, painted by Sara Sax in a 'Vellum' glaze, impressed with firm's marks, Commercial-Club of Cincinnati 1880-1905 and artist's initials, the silver engraved Mr. Thompson, 5¼ in. high. **£250-325**

A Macintyre cylindrical vase, painted with iron red and blue flowers on a salmon pink and royal blue ground, enriched with gilded panels, 10 in. high, printed Macintyre mark. **£150-200**

A Moorcroft Macintyre 'Florian Ware' vase, painted in blues, olive and yellow with cornflowers, 25 cm. high, Macintyre marks and signed W. Moorcroft in green. **£190-250**

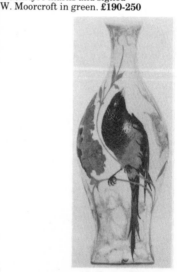

A Rozenburg eggshell porcelain cup and saucer, by Samuel Schellink, both with printed Rozenburg mark, artist's monogram and cypher for 1903, saucer 13.3 cm. diam., cup 6 cm. high. **£500-600**
The Rozenburg workshops in The Hague undoubtedly produced the finest of all Art Nouveau ceramics. The products of this workshop were much more delicate than those of other Art Nouveau potters, since most Rozenburg wares were made of wafer thin porcelain as opposed to the 'thicker', 'heavier' pottery wares produced by most other Art Nouveau potters.

A Rozenburg 'eggshell' vase, decorated by Sam Schellink, finely painted in browns, yellows and greens, 16.5 cm., printed factory mark, artist's monogram and date letter for 1902. **£700-£800**

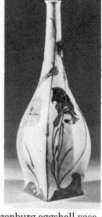

A large Rozenburg glazed earthenware vase, decorated by Hartinek, painted in green, rust, amber and turquoise against a brown ground, 56 cm., stencilled factory mark, incised number W 32V painted 349, and letter 'H' date mark for 1903. **£250-350**

A Rozenburg eggshell vase, decorated with pinks in Art Nouveau taste, 28 cm. high, printed mark and painter's mark of Schnelling. **£1,000-1,500**

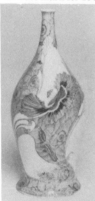

A Rozenburg eggshell porcelain two-handled vase, painted by W. P. Hartring, painted in polychrome with salamanders and thistles on a white ground, printed Rozenburg mark, artist's initial, and cypher for 1904, slight restoration to rim, 24.5 cm. high. **£1,400-1,800**

A Rozenburg eggshell porcelain vase, with lilac and yellow flowers on an ivory ground, with stencilled firm's marks, painted 991, with an insect and artist's initials, 7 in. high, c. 1900. **£1,200-1,500**

A porcelain vase, by Sèvres, decorated by Taxile Doat in mustard, brown and blue, with firm's marks, artist signed and dated, 7½ in. high, 1907. **£175-£210**

An attractive Rozenburg twin-handled pottery vase, painted in violet, blues, greens, yellows and browns with a batik-style of lilies-of-the-valley and leaves, 27.5 cm. high, painted factory marks and anchor date code for 1899. **£600-650**

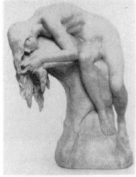

'La Roche Qui Pleure', a Sèvres biscuit porcelain study, after a model by Hector Lemaire, 42 cm., incised title, artist's facsimile signature stamped 'Sèvres', c. 1900. **£440-540**

'Winter', a Royal Austrian 'Vienna' plate, painted after a design by Alphonse Mucha, 24.75 cm., signed, painted and printed factory mark, painted title and artist's name, c. 1900. **£180-220**

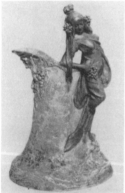

An Ernst Wahliss pale green lustre glazed porcelain pitcher, 28.5 cm., printed factory mark 'EW Turn Vienna', impressed 'Made in Austria 45694', painted number '4569 339 5', c. 1900. **£200-300**

A fine pottery vase, by Tiffany Studios, New York, in a mottled-green semi-gloss glaze, inscribed with conjoined initials L.C.T., 11 in. high, c. 1905. **£380-460**

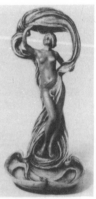

A Wahliss turn glazed earthenware lamp, printed factory mark, stamped 'Made in Austria' '482222', 52.5 cm., 1900. **£990-1,200**

An iridescent pottery vase, 'LA SA', by Weller, golden iridescent ground in tones of pink and green, 6½ in. high. **£150-200**

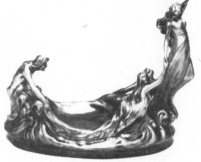

An iridescent pottery vase by Jacques Sicard for Weller, the purple ground with golden daisies, signed, 5¼ in. high. **£100-125**

A Zsolnay lustre glazed earthenware dish, in rich green/purple/gold glaze, 22.75 cm., applied and impressed factory mark, numbered '7195 36', c. 1900. **£650-750**
Vilmos Zsolnay from Hungary produced many pieces which display a strong Art Nouveau style. His work is characterised by the use of deep blue, red, purple and green glazes.

A Zsolnay earthenware vase, the body in a crimson glaze and the neck with iridescent blue and green flowers, moulded with firm's marks and impressed 5999M21, 11½ in. high. **£100-£150**

A large Zsolnay moulded lustre vase, in purple, red and gold and green lustre, base with Zsolnay mark and side with an impressed symbol, 36.5 cm. high. **£4,000-£5,000**
This vase was specially produced for the Paris Exhibition of 1900.

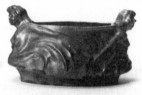

An earthenware vase, moulded with busts of women with bat wings in an iridescent olive-grey and mauve glaze, Belgian, impressed CERAMIQUE RAMBERVILLERS, 8½ in. long, c. 1900. **£200-300**

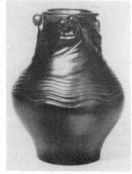

An attractive Zsolnay lustre vase, the cylindrical neck having the head and shoulders of a man and four maidens emerging from waves, all beneath a vivid glaze of peacock, green and rust tones, 15 cm. high, relief factory mark in circle. **£450-600**

CERAMICS

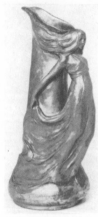

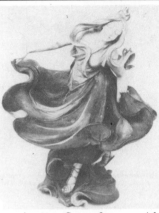

A pottery figure of a young girl, 43 cm., factory marks, c. 1900. **£250-350**

A Zsolnay lustre glazed earthenware jug, the handle finely modelled as a young woman in yellow/green and brown lustre glaze, 22 cm., embossed factory mark, c. 1900. **£500-700**

'Daphne', a Continental porcelain bust of a young girl, wearing plum-coloured drapes, the head and shoulders green-glazed, 14¼ in. high. **£50-70**

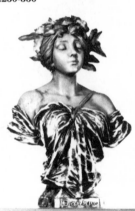

GLASS

It has been said that it was the glass workers who, more than any others, truly captured the spirit of Art Nouveau and gave it form. In their workshops, limitless new techniques were evolved to colour glass, to texture it and shape it in ways that had never been dreamed of before. Old and long-established techniques, too, were dusted off and revitalised by craftsmen determined to employ any means to give expression to their vision.

Probably the greatest craftsman of his time was Emile Gallé, and from his workshops poured a torrent of glasswares illustrating a phenomenal range of techniques. Palely tinted transparent glass characterised his early products, often enamelled in thick relief and harmonious colours. Surfaces were treated with acid or had glass cabochons added to enhance textural interest. His 'claire de lune' glass dates from this period; an opalescent glass which, by transmitted light revealed a brilliant sapphire colouration. At the exhibition of 1889, Gallé revealed his 'verre double'; vases of a single colour glass encased in one or more layers of different glass which were subsequently etched selectively to produce designs in relief. Similarly layered vases would be wheel carved to achieve the subtlest of cameo effects.

But perhaps the most dramatic of Gallé's techniques was his 'marguetrie de verre'. This called for a marquetry or mosaic design of pieces of semi-molten coloured glass to be set into the body of a vase or bowl while it was still soft. It was a hazardous technique during the application of which many pieces cracked. The finest generally bear Gallé's own signature engraved with a fine point in spidery letters.

Other craftsmen concentrated on rediscovering the ancient art of pâte de verre. This involved a mixture of finely powdered glass, water, adhesive and oxides being blended into a paste, packed into a mould until it was firm enough to work on, before firing at a high temperature. It is generally accepted that the only British glassmaker of note during this period was the Scottish firm of James Couper and Sons, Glasgow, whose 'Clutha' glass (the word is old Scots for cloudy) achieved considerable popularity just before the turn of the century.

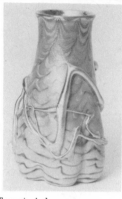

A 'Trevaise' glass vase, attributed to the Alton Manufacturing Company, the opaque chartreuse glass with wide iridescent gold waves and thick iridescent gold applied threading, unsigned, 6¼ in. high, c. 1910. **£200-300**

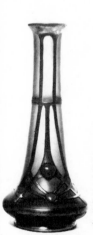

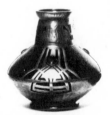

A copper-mounted Bakalowits glass vase, from the Vienna School of Arts and Crafts under Kolo Moser, probably by Antoinette Krasnick, in deep purple glass decorated with patches of peacock and green lustre, the openwork copper mount set with foil-backed cabochons in rich blue and green enamel, 15 cm., 1900-03. **£120-£170**

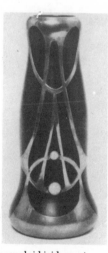

A copper-mounted Bakalowits glass vase, from the Vienna School of Arts and Crafts under Kolo Moser, probably by Antoinette Krasnick, in clouded green glass with openwork mount in part-silvered copper, set with green glass cabochons, 31.6 cm., 1900-03. **£200-300**

A copper overlaid iridescent glass vase, from the Vienna School of Arts and Crafts, under Kolo Moser, probably designed by Antoinette Krasnick, the purple body with light surface lustre, overlaid with copper, set with two turquoise-coloured stones, 25.5 cm., c. 1900. **£190-250**

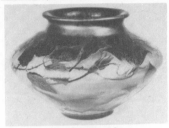

An attractive d'Argental cameo glass vase, the body overlaid with deep brown glass, acid-etched with sinuous branches of roses, 16.5 cm. high, signed in cameo d'Argental. **£250-350**
There were many imitators of the Gallé cameo glass wares, among these are d'Argental, Richard, Arsall and Delatte.

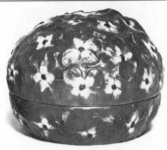

A pâte-de-verre covered jar, by G. Argy-Rousseau, moulded with deep amethyst lilacs, signed G. ARGY-ROUSSEAU, 4 in. diam. **£600-800**
Pâte-de-verre is a term used to describe glass paste fired and solidified at a high temperature.

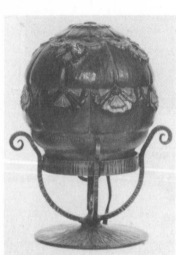

A mounted pâte-de-verre veilleuse, by G. Argy-Rousseau, with bands of red and brilliant blue flowerheads on a mottled mauve and lilac ground, on a martelé wrought-iron mount, 7¾ in. high. **£1,000-1,250**

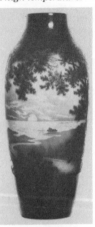

A double overlay glass vase, by d'Argental, the white ground overlaid with blue and black, etched with a lakeland scene, inscribed signature, 14 in. high. **£650-850**

An attractive Argy-Rousseau pâte-de-verre wall light, in tones of pale amber, grey and amethyst, 18.5 cm. high, signed G. Argy-Rousseau, with wall fitments. **£80-120**

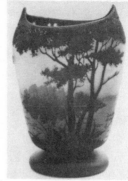

A Baccarat Art Nouveau glass and ormolu-mounted encrier, the clear glass moulded in a 'cire perdue' technique, applied with a gilt-bronze figure of a mermaid, the base applied with 2 gilt-bronze foliage-moulded inkwells, 37 cm. wide. **£1,500-£2,000**
The 'cire perdue' technique of casting consists of making a mould using a model of wax (cire), which is melted once the mould is formed and poured away, or lost (perdue), before the glass is poured in.

A Daum cameo glass landscape vase, in grey glass overlaid with deep blue/green and etched with a river scene, 22.5 cm., cameo mark 'Daum Nancy', c. 1900. **£700-900**

DAUM BROTHERS, Auguste (1853-1909), Antonin (1864-1930)

Makers of decorative domestic glassware, the Daum Brothers turned to art glass production following the Paris Exhibition in 1889. Since they worked in Nancy, it is not unnatural that they should have been greatly influenced by Gallé — with whom they are invariably unfavourably compared. Inevitable as such comparison is, it is unfortunate, because their work is highly competent and frequently displays a high standard of artistic merit.

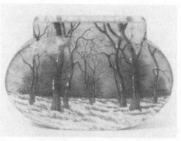

A Daum 'Winterscape' cameo vase, the orange mottled body acid-etched and painted in brown, 11.5 cm. high, signed on base 'Daum Nancy'. **£150-250**

A Daum cameo glass vase, etched and painted with brown and black sailing boats on a matt yellow and apricot ground, 4¼ in. high, painted mark Daum Nancy. **£100-130**

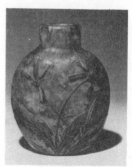

A Daum etched and enamelled vase, overlaid and painted in shades of yellow and green with mottled amber ground, enamelled signature Daum Nancy France, 18.5 cm. high. **£360-420**

A large Daum cameo glass flower bowl, in grey glass overlaid with green/turquoise/brown and blue glass, 13.75 cm., cameo mark 'Daum Nancy', c, 1900, with a pierced gilt-metal circular cover. **£620-800**

A Daum cameo glass vase, on stepped circular silver foot, the thick opalescent glass with blue mottling, overlaid in indigo and etched, base engraved Daum Nancy, 24.8 cm. high. **£1,500-£2,000**

An enamelled, etched and carved glass vase, by Daum, depicting gentians in blossom in naturalistic colours, engraved signature, 13¾ in. high. **£1,000-£1,250**

A Daum cameo glass vase, in grey glass streaked with red, overlaid in mottled red/orange and yellow/green, 40 cm. cameo mark 'Daum Nancy', c. 1900. **£550-650**

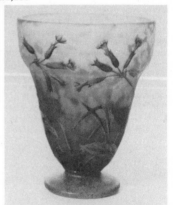

A Daum cameo glass vase, the body of mottled honey and rose tone, acid-etched with relief decoration of cowslips painted in naturalistic colours, 20.5 cm. high, signed Daum, Nancy, France. **£480-600**

A Daum etched and enamelled cameo glass vase, of oval section, the pale pink ground overlaid and painted in realistic colours, base enamelled Daum Nancy, 23 cm. high. **£580-680**

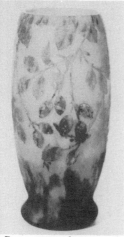

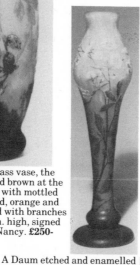

A Daum cameo glass vase, the honey body shaded brown at the base and overlaid with mottled glass of yellow, red, orange and green, acid-etched with branches of rose hips, 21 cm. high, signed in cameo Daum, Nancy. **£250-£350**

A Daum double overlay vase, the mottled pale green-blue ground overlaid in shades of purple, relief signature Daum Nancy above the Cross of Lorraine, 34.8 cm. high. **£500-700**

A Daum etched and enamelled glass vase, the matt ground in shades of peach, rose pink and green, enamelled Daum Nancy above the Cross of Lorraine, 40.5 cm. high. **£800-850**

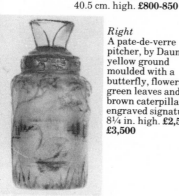

Right
A pate-de-verre pitcher, by Daum, the yellow ground moulded with a butterfly, flowers, dark green leaves and two brown caterpillars, engraved signature, 8¼ in. high. **£2,500-£3,500**

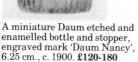

A miniature Daum etched and enamelled bottle and stopper, engraved mark 'Daum Nancy', 6.25 cm., c. 1900. **£120-180**

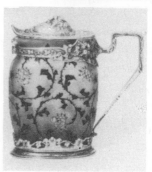

An attractive Daum silver-mounted glass ewer, acid-etched and enamelled with branches of thistles, 11 cm. high, signed Daum, Nancy. **£600-800**

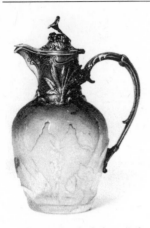

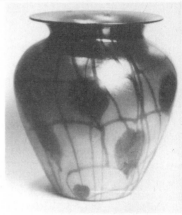

A silver and etched glass pitcher, by Daum and Gorham, the silver handle and mount with a floral repoussé design, with a gilt signature and firm's hallmarks, 9¼ in. high. **£325-425**

An Art Nouveau iridescent glass vase, by Victor Durand, with heart and clinging vine decoration, 6 in. **£300-500**

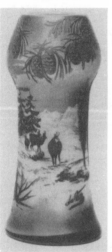

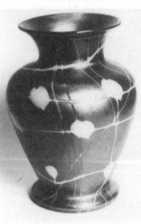

A late Art Nouveau iridescent glass vase, by Victor Durand, with a heart and clinging vine decoration, c. 1920, 6½ in. high. **£300-500**

A scenic cameo vase, by De Vez, with a finely carved winter landscape and a band of carved pine cones at the neck, signed in cameo, 8½ in. high. **£550-700**

A Despret pâte-de-verre stemmed dish, moulded in shades of blue and green glass, 10 cm., engraved on the underside 'Despret 867', c. 1915. **£500-600**

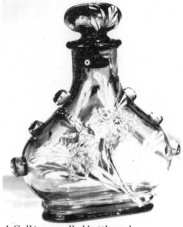

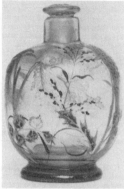

A Gallé enamelled bottle and stopper, in clear sepia glass, decorated in pastel coloured enamels and gilt, base inscribed E. Gallé de Nancy with E.G. vertically and a Cross of Lorraine between, and above com 10, 21 cm. high. **£250-350**

A Gallé enamelled glass bottle and stopper, the smoky amber glass body finely enamelled, detailed in pink, red, black and gold, 10 cm., enamelled mark 'E. Gallé Nancy', 1890's. **£660-800**

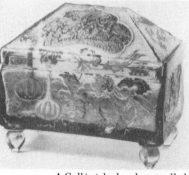

An early enamelled and etched glass cache-pot, clear topaz glass enamelled with russet, pink and ochre, enriched with gilding, gilt relief signature, Gallé, 20.5 cm. wide. **£400-600**

A Gallé etched and enamelled glass casket, in clear amber glass, detailed in naturalistic enamels and gilding, 15.5 cm., 1890's. **£2,800-3,200**

A large etched and enamelled glass bowl, the green glass enamelled in red, white, yellow, green and turquoise, signed Émile Gallé delt. ft. Serie C déposé around a mushroom on the base, 13⅜ in. wide. **£1,400-£1,800**

A Gallé etched and enamelled vase, in pale green glass overlaid in milky-green glass, heightened with gilding, 9 cm., cameo mark 'Gallé', c. 1900. **£260-320**

An etched glass vase, by Emile Gallé, etched with a Persian warrior, the reverse with Persian calligraphy, cameo signature, 4⅞ in. high. **£1,500-£2,000**

An early Gallé enamelled vase, of Islamic inspiration, etched and enamelled with magnolias, bamboo and dragonflies, on smoky glass, engraved E. Gallé Nancy twice, 36 cm. high. **£4,000-5,000**

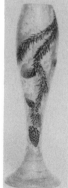

A fine two colour layer cameo glass vase, by Gallé, c. 1900, 11½ in. high. **£500-700**

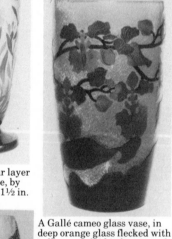

A Gallé cameo glass vase, in deep orange glass flecked with yellow, overlaid in brown and etched, 19.5 cm., cameo mark 'Gallé', c. 1900. **£1,000-1,200**

An enamelled and etched bottle vase, the amber glass enamelled in pink, white and autumnal hues, enriched with trace of gilding, etched mark Cristallerie d'Emile Gallé, model et décor déposés, 40 cm. high. **£800-1,000**

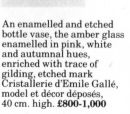

An etched and enamelled glass vase, by Emile Gallé, the white-speckled green-tinted ground overlaid with white, with enamelled signature, 13½ in. high. **£600-700**

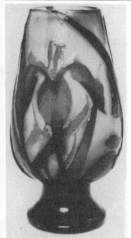

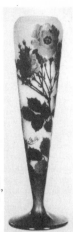

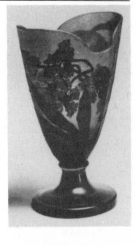

A Gallé cameo glass vase, in grey glass overlaid with purple and brown and etched, polished, 22.5 cm., cameo mark 'Gallé', c. 1900. **£600-800**

An overlay glass vase, the amber and yellow ground overlaid in brown and etched, signed Gallé in the overlay, 16½ in. high. **£2,100-2,300**

An overlaid spill vase, the yellow oil ground with mauve rose decoration, by Gallé, 15 in. high. **£680-750**

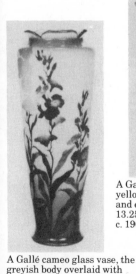

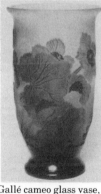

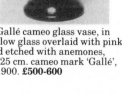

A Gallé cameo glass vase, in yellow glass overlaid with pink and etched with anemones, 13.25 cm. cameo mark 'Gallé', c. 1900. **£500-600**

A Gallé cameo glass vase, the greyish body overlaid with orange and deep ruby glass, acid-etched and polished, signed 'E. Gallé', 45 cm. high. **£2,200-2,600**

A Gallé cameo glass vase, in grey glass overlaid with red and etched with sprays of wild roses, 44 cm., cameo mark 'Gallé', c. 1900. **£1,100-1,500**

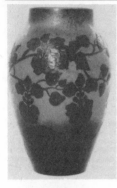

A small Gallé carved cameo glass vase, in opaque milky-green glass, 9.5 cm., underside with impressed mark 'Gallé modèle et décors déposés', c. 1900. **£440-£520**

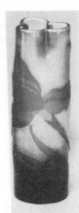

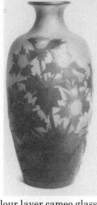

A fine 3 colour layer cameo glass vase, by Gallé, 9½ in. high. **£700-900**

An overlay glass vase, the milky green ground overlaid in violet and engraved, small crack to lip, engraved Gallé on the base, 8½ in. high. **£850-1,000**

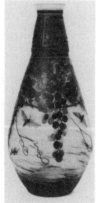

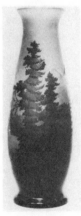

A double overlay glass vase, by Emile Gallé, the blue-streaked yellow ground overlaid with amber and dark amber, and etched with cameo signature, 21¾ in. high. **£1,500-1,700**

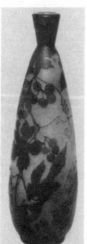

A 3 colour layer cameo glass vase, by Gallé, c. 1900, 8½ in. high. **£450-650**

A Gallé cameo glass vase, in orange glass overlaid with brown and etched with fruiting vine, 24.25 cm., cameo mark 'Gallé', c. 1900. **£500-700**

A Gallé cameo glass landscape vase, overlaid with brown and blue and etched with a mountain landscape, 32 cm., cameo marked 'Gallé', c. 1900. **£750-£1,000**

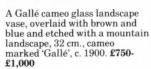

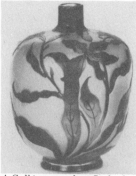

A Gallé cameo glass flask, the greyish body overlaid with orange and ruby glass, signed 'Gallé' on a four-leaved clover, 12.5 cm. high. **£380-500**

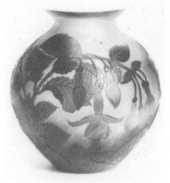

A fine 3 colour layer cameo glass vase, by Gallé, 5¼ in. high. **£400-600**

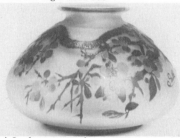

A 3 colour cameo glass vase, designed with Japanese inspiration, by Gallé, c. 1900, 10½ in. diam. **£1,200-1,500**

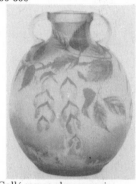

A Gallé cameo glass vase, in grey glass tinted pink, overlaid in white and green, cameo mark 'Gallé', 30 cm., c. 1900. **£550-650**

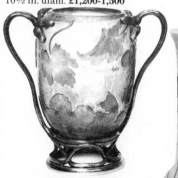

A silver-mounted double-overlay glass vase by Emile Gallé, engraved signature; the handled silver mount stamped SCHWARZ & STEINE and W & C, 7½ in. high. **£2,500-£3,000**

A 2 colour cameo glass vase by Gallé, 14¾ in. high. **£450-650**

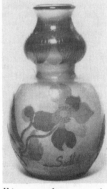

A Gallé cameo glass vase, the grey glass body overlaid with clear brown glass and etched, 24 cm., cameo mark 'Gallé', c. 1900. **£900-1,100**

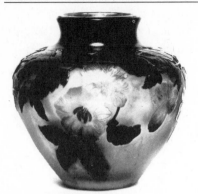

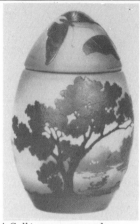

A Gallé cameo glass vase, the grey glass internally decorated with patches of yellow, overlaid in blue and mauve and etched with flowering branches, 14.6 cm., cameo mark 'Gallé', c. 1900. **£300-450**

A Gallé cameo vase and cover, the greyish body rose and green tinted and overlaid with pale and deep brown glass, signed in cameo Gallé, 14.5 cm. high. **£900-1,100**

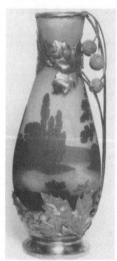

A mould-blown double overlay glass vase, by Emile Gallé, the frosted green glass overlaid with sienna brown, finely etched, heightened with yellow, cameo signature, 8 in. high and 11 in. diam. **£4,000-5,000**

A scenic silver-mounted and overlaid glass vase, by Emile Gallé, the brown landscape on a yellow and white ground, the silver mount cast with a chestnut spray, with French hallmark, 17 in. high. **£3,000-£3,300**

A 3 coloured layer mould-blown 'Souffle' vase, of Japanese inspiration, by Gallé, c. 1890, 9½ in. high. **£2,000-3,000**
The mould-blown vases conceived by Emile Gallé were a series of acid cameo vases in very high relief. Typical examples involve designs of ripe fruit such as the above example.

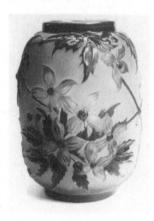

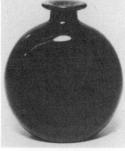

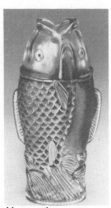

A Gallé purple glass flask, streaked internally with yellow/grey, 13 cm. body with incised signature, 'Gallé', c. 1900. **£500-600**

An unusual metallic glass vase, by Emile Gallé, the marine blue glass profusely decorated with iridescent metallic surface speckling, inscribed signature, 16⅜ in. high. **£4,000-5,000**

A fine and heavy glass vase, enamelled in greyish-green, and heightened with gilt, engraved E. Gallé on the base, 11⅛ in. high. **£4,500-6,000**
Inspired by the Buddhist sign 'Yu' symbolising conjugal luck.

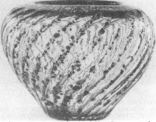

An unusual internally decorated and cut Gallé glass bowl, the underside with engraved mark 'E. Gallé', 12.5 cm., c. 1885. **£820-950**

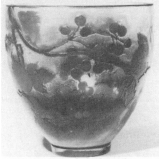

A Gallé fine polished overlay cache-pot, in shades of sea-green and milky-white, signature Emile Gallé within a vine leaf, Nancy, modèle et décor déposés, small chip to rim, 15.5 cm. **£550-£650**

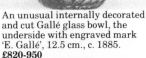

A Gallé cameo glass hanging shade, the grey/pink body overlaid in blue and etched with flowering creeper, with hanging chains and fitments, 49.5 cm. diam., cameo mark 'Gallé', c. 1900. **£1,000-1,200**

A Gallé cameo dish, in the Egyptian taste, the clear ground of bluish tint overlaid in blue and translucent green and acid etched, imitation Chinese signature, 28 cm. wide. **£1,000-£1,500**

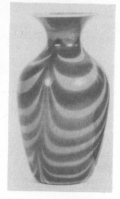

A glass vase, by Imperial, with dark blue bands on a bright orange ground, 8 in. high. **£100-£125**

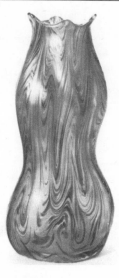

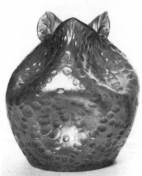

A Legras cameo glass vase, in grey/green overlaid in dark and lighter shades of green, 24.5 cm., cameo mark 'Legras', c. 1900. **£330-400**

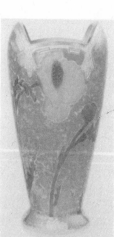

An Austrian iridescent glass vase, in violet, gold and blue, possibly Kralik, 20 cm. high. **£110-190**

A Loetz iridescent glass vase, having a surface textured with dimples and exhibiting a golden lustre, with traces of peacock blue, 16.5 cm. high. **£220-280**

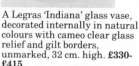

A Legras 'Indiana' glass vase, decorated internally in natural colours with cameo clear glass relief and gilt borders, unmarked, 32 cm. high. **£330-£415**

Auguste Legras worked in Paris producing enamelled and cameo glass imitating the style of Emile Gallé

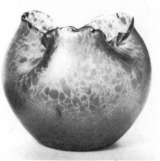

A Loetz iridescent glass vase, exhibiting a golden iridescence applied in random splashes with tones of peacock blue, 14.5 cm. high. **£250-350**

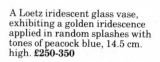

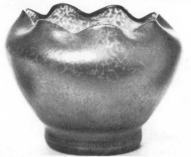

A Loetz iridescent glass bowl, with a vivid peacock blue iridescence in random splashes, 22 cm. diam. **£220-280**

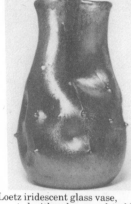

A Loetz iridescent glass vase, decorated with pale peacock/gold lustre, 24 cm., c. 1900. **£400-500**

A Loetz iridescent glass vase, of Persian rosewater sprinkler form, the green glass body having dimpled sides, 25 cm. high. **£330-430**

A glass vase by Loetz, designed by Candia Silberiris, of transparent glass with numerous small prunts and a heavy gold iridescence, unsigned, 9½ in. high. **£200-250**

An iridescent glass vase, attributed to Loetz, in ruby glass decorated with swirling trails of silver/turquoise iridescence, 23.4 cm., c. 1900. **£450-550**

A Loetz style iridescent vase, with a waved and combed band of violet iridescence on an amber ground, 3¼ in. high. **£200-250**

49

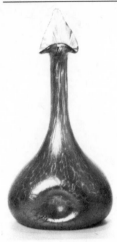

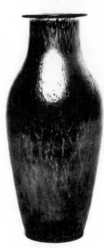

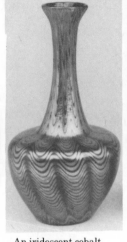

A Loetz iridescent glass vase, of Persian rosewater sprinkler form, covered overall with gold splashes exhibiting pink tones, 24 cm. high. **£260-360**

An iridescent glass vase attributed to Loetz, in clear glass decorated with mottled trails of yellow and with overall bronze iridescence, 24 cm., c. 1900. **£120-200**

An iridescent cobalt bottle, attributed to Loetz, decorated with greenish-gold pulled thread design, 28.5 cm. high. **£680-800**

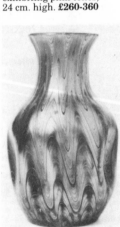

An iridescent glass vase, attributed to Loetz, 21 cm., c. 1900. **£340-400**

Right
A glass vase, by Loetz, the opalescent glass with iridescent gold scrollwork and applied gold-lined caramel 'lily-pads', inscribed Loetz Austria, 9 in. high. **£650-850**

Above
A glass vase, by Loetz, the clear glass with iridescent gold mottling and a heavy brown iridescence, unsigned, 9½ in. high. **£200-250**

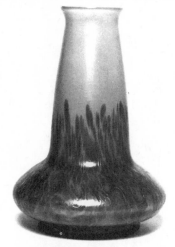

An iridescent glass vase, attributed to Loetz, the yellow glass body decorated with dappled amber lustre, 26 cm., c. 1900. **£150-250**

A glass vase, by Loetz, the clear and sky-blue glass with spiralling iridescent gold waves, inscribed 'Loetz, Austria', 8¼ in. high. **£300-400**

Right

A pair of Loetz vases, the bodies with peacock blue iridescence in random splashes, each enclosed with a 'Juventa' pewter mount, 31 cm. high. **£450-550**

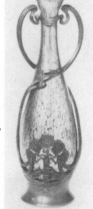

A Loetz iridescent glass vase, in pink/brown glass, 24 cm., engraved mark, 'Loetz Austria', c. 1900. **£850-950**

A Müller Frères cameo glass vase, the greyish body overlaid with two tones of ruby glass, acid-etched with roses, 15.5 cm. high, signed in cameo Müller Fres Lunéville. **£250-350**
The Müller Frères of Lunéville trained with Emile Gallé prior to establishing their own glassworks, hence their products do bear a resemblance to those of Gallé.

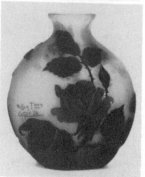

51

A Müller Frères cameo glass landscape vase, overlaid in purple glass, with cameo title 'Biarritz', 22.75 cm., lightly incised mark 'Müller Frères, Lunéville', c. 1910. **£250-350**

An unusual Loetz cameo glass vase, the body of rich red tone overlaid with glass showing a lilac-silver iridescence, acid-etched with foliage and flowers, 25.5 cm. high. **£900-1,000**

A Loetz cameo glass vase an cover, in yellow glass overla with brown and etched with leaves, cameo mark 'Loetz', 23.5 cm., c. 1900. **£240-300**

Left
A mounted green iridescent glass vase, in the style of Loetz, in a peacock blue/green iridescence, the rim mounted with a white metal, 5½ in. high. **£120-200**

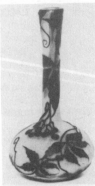

A Müller Frères cameo glass vase, in yellow glass overlaid with red/brown and etched with fruiting vine, 17 cm., cameo mark 'Müller Fres Lunéville', c. 1900. **£350-450**

Right
An overlay glass vase, by Müller Frères, the sky-blue ground overlaid with purple, etched with thistles and the Cross of Lorraine, inscribed Müller Croismare, 15¾ in. high. **£800-£1,000**

A Müller carved cameo gl vase, the body in grey glas overlaid in pink and murk green, polished, 19 cm., underside incised 'Müller Croismare pr Nancy', c. 19 **£400-500**

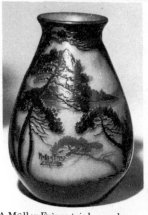

A double overlay glass vase, by Müller, the translucent ground overlaid in orange and dark grey-blue, etched with a mountainous scene, cameo signature, 15¼ in. high. **£1,000-£1,500**

A Müller Frères triple overlay vase, the amber ground overlaid in ochre, deep blue and black, and etched with a wooded river landscape, relief signature Müller Fres Lunéville, 22 cm. high. **£800-1,000**

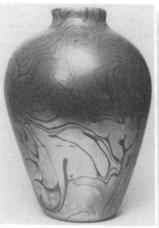

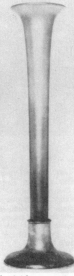

A Favrile glass vase, by Tiffany Studios, the transparent red-amber glass overlaid with olive-grey and green scrollwork, inscribed E160 L.C.T., 17 in. high. **£1,750-2,100**

'Favrile' was a trade name used by Tiffany and comes from an old English word meaning hand-made.

An overlaid glass vase, by Müller Frères, the pale clear white-green ground overlaid with creamy-white and opaque white, finely etched with a flower spray, etched firm mark, 10½ in. high. **£1,000-1,200**

An iridescent glass spill vase, in metallic pink enamel shading to gold, 34.25 cm. vase engraved 'L.C.T. Favrile' stamped 'L.C. Tiffany Furnaces Inc 151' and with company trade mark, c. 1900. **£380-420**

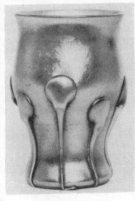

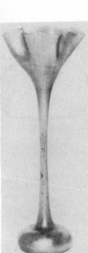

A small Tiffany iridescent glass vase, decorated with overall pink/gold lustre, 8 cm., engraved mark 'L.C.T.M. 6251', 1900. **£250-300**

An attractive Tiffany iridescent glass vase, pa green/gold iridescence w trailed decoration, 9.5 c the underside engraved 'L.C.T. B806', 1894. **£48 £580**

A Tiffany iridescent glass vase, overall pink/gold lustre, crackled at the rim, 45.5 cm. max. height, engraved mark 'L.C.T. 9583A', affixed manufacturers' paper label, 1906. **£880-1,080**

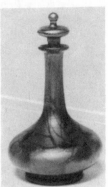

A Tiffany iridescent glass perfume bottle and stopper, in pale gold lustre and green, 11.5 cm., c. 1900. **£330-400**

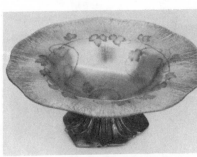

A Tiffany Favrile glass and ormolu-mounted grape-dish, the greenish-golden glass with crackled iridescence, engraved with a continuous band of leafy vine, on an ormolu pedestal, bas stamped Louis C. Tiffany Furnaces, Inc. Favrile 500, 31.5 cm. diam. **£400-500**

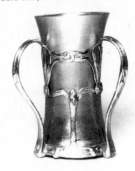

A silvered-bronze mounted Favrile glass loving cup, by Tiffany Studios, the base inscribed B.P. 501 FAVRILE and signed LOUIS C. TIFFANY, 8¾ in. high. **£250-350**

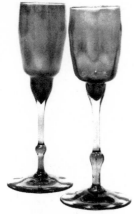

Four Tiffany iridescent glass hock glasses, each with slender bowls in milky gold glass, supported above a milky-green glass stem on flat circular clear foot, 19 cm., three with affixed paper labels for the Tiffany Favrile Glass Company, each with engraved initials 'L.C.T.', engraved numbers F2592, F2610, F2594, F2616, 1896. **£600-700**

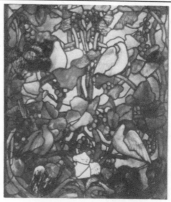

A leaded glass panel, by Tiffany Studios, depicting 4 white doves amongst green leaves and violet-brown brambles on a blue, cobalt and turquoise ground with amber and opalescent 'jewels', unsigned, 24¼ by 28½ in. **£3,000-4,000**

Below
A double overlay glass vase, the milky white ground overlaid in green and amber, signed in the overlay, 21⅝ in. high. **£1,100-£1,200**

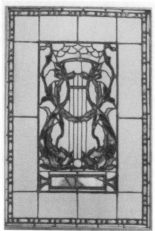

A leaded glass window, attributed to Tiffany Studios, with two blue, turquoise, purple and red seahorses, bordered by opalescent glass 'jewels', unsigned, 17 by 25¾ in. **£1,000-£1,500**

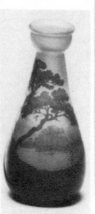

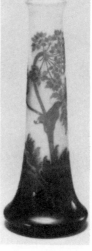

A double overlay glass vase, the blue ground overlaid in tones of purple with tall trees in an extensive river landscape, signed in the overlay, 7¼ in. high. **£550-650**

55

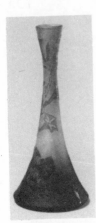

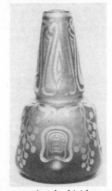

An unusual etched iridescent glass vase, in bubbled olive-green glass etched with a stylised design detailed with turquoise lustre, 20.4 cm., probably Austrian, c. 1900. **£150-250**

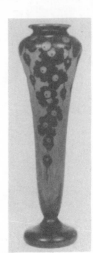

An overlay glass vase, the milky white ground merging to orange towards the neck, overlaid in blue, signed in the overlay, 18⅜ in. high. **£1,000-1,500**

A tall 'Le Verre Francais' cameo vase, the streaked red and yellow body overlaid with brown, acid-etched with trailing flowers, 59 cm. high, signed 'Le Verre Francais'. **£800-1,000**

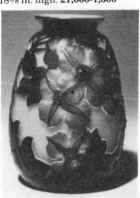

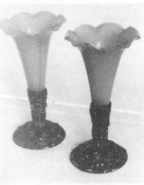

A mould-blown and triple overlay oviform glass vase, the matt pale salmon ground mould-brown and etched in white, deep pink and maroon, cameo signature. **£1,800-£2,200**

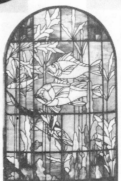

A pair of Art Nouveau vases, with green glass and plated brass bases, 12 in. high, c. 1910. **£25-30**

Left
A fine stained glass casement window, depicting an underwater scene in blue, amber and green, American, c. 1890, 54½ by 36½ in. including a wooden frame. **£2,000-2,500**

LAMPS

It was during the closing years of the nineteenth century that electricity began to be used for domestic lighting, and it is hardly surprising that its cause was rapidly espoused by workers in metal and glass. Far and away the most popular and fashionable designer of lamps for the new electric lights was Louis Comfort Tiffany (1848-1933) an American aesthete with a highly developed talent for marketing. His work-shops produced a wide range of lamps characterised by the use of stained glass window techniques employing iridescent coloured glass to create the effect of beauty at all times, whether illuminated from within by the lamp, or not.

The French glassmaker, René Lalique, also developed the tech-nique of building electric lights into bases on which he placed glass sculptures.

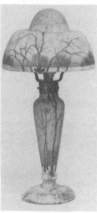

An etched and enamelled glass table lamp, by Daum, base with enamelled signature, 17½ in. high. **£1,200-2,000**

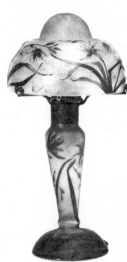

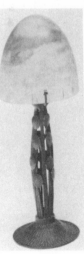

A Daum etched and enamelled glass lamp, 44 cm., etched mark 'Daum Nancy', c. 1900. **£1,600-2,000**

A double overlay glass lamp, by Daum, of yellow and pink streaked translucent glass overlaid with light red and amethyst etched with amaryllis, cameo signature, 14½ in. high. **£1,500-2,000**

A double overlay glass table lamp, by Emile Gallé, the frosted pale violet ground shading to yellow at the peak and overlaid with shades of purple, etched both with cameo signature, 17 in. high, 8½ in. diam. of shade. **£1,500-2,500**

Right
A glass and wrought iron table lamp, by Daum, the shade of yellow, red and violet-streaked glass, engraved signature, 15 in. high. **£400-500**

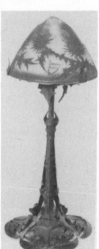

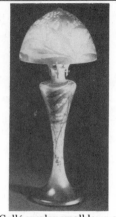

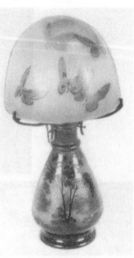

A Gallé overlay small lamp and shade, in brown on lime green, each piece with engraved signature, fitted for electric light, 43 cm. high. **£3,000-4,000**

An overlay glass and wrought iron table lamp, by Daum, the shade of translucent red and yellow glass overlaid with dark amethyst etched with thistles, cameo signature, the base with gilded crosses of Lorraine, unsigned, 14½ in. high. **£750-£1,000**

An overlay glass table lamp, by Emile Gallé, the pink ground shading to white, overlaid with maroon etched with umbels and foliage, with cameo signature, 17½ in. high, 8 in. diam. of shade. **£2,500-3,500**

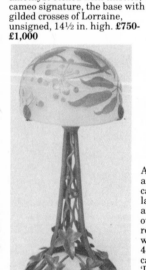

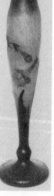

A Daum etched and carved cameo glass lamp vase, in amber glass overlaid in deep red, the ground wheel faceted, 45.75 cm., carved mark 'Daum Nancy', c. 1900. **£800-£1,000**

A double overlay glass and wrought iron table lamp, by Emile Gallé, translucent glass overlaid in lime-green and pale violet etched with floral sprays, cameo signature, unsigned, 13 in. high. **£600-900**

A fine Gallé acid-etched table lamp and shade, signed, mounted in bronze, with electric light fittings, 40 cm. high. **£1,100-1,400**

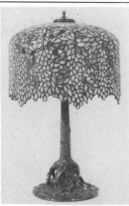

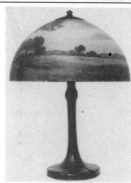

A fine Wisteria leaded glass and bronze table lamp, by the Handel Company, Meriden, Conn., c. 1900, 18 in. diam. of shade, 29 in. high. **£5,000-7,000**

A bronze patinated metal and painted glass table lamp, 53 cm., shade signed 'Handel 7203', base with affixed woven silk label 'Handel', c. 1910. **£440-500**

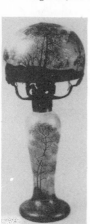

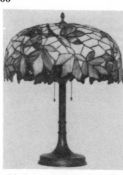

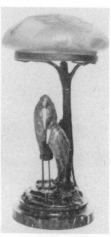

A table lamp, with leaded glass shade in reds, greens and cream, on a bronze stand, 58 cm., base stamped 'Gorham Co. QV293', c. 1900. **£1,300-1,500**

A French Art Nouveau table lamp and shade, with landscape decoration, by Legras, 15 in. high. **£420-540**

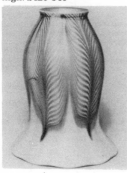

An overlay glass shade, on a bronze and ivory base, by Emile Gallé, the base attributed to Peter Tereszczuk, the shade of amber-orange glass overlaid with violet and etched with clematis, with cameo signature, the bronze base raised on a circular granite plinth, unsigned, 18 in. high, 7¾ in. diam. of shade. **£2,000-3,000**

A Quezal iridescent glass shade, with feathered panels of blue and gold lustre against a white lustre ground, engraved mark 'Quezal', 15.25 cm., c. 1910. **£130-170**

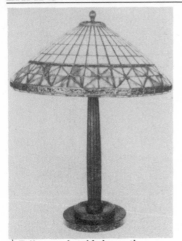

A Tiffany-style table lamp, the leaded shade with panels of apple green and emerald green, on a green patinated metal column, American, 16.5 cm. high. **£400-490**

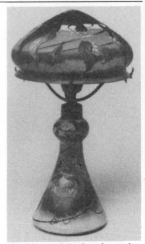

A double overlay glass lamp, by Val St. Lambert, overlaid in shades of purple, lilac and white etched with flowers, the firm's initials in cameo, 14 in. high. **£2,500-3,500**

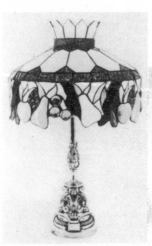

An Art Nouveau lamp, with a Tiffany-style shade, 2 ft. 9 in. high. **£550-700**

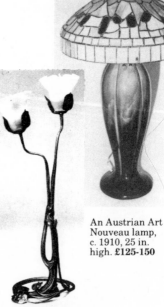

An Austrian Art Nouveau lamp, c. 1910, 25 in. high. **£125-150**

A gilt-bronze and glass two-branched candelabrum, by Louis Majorelle, cast as a monnaie du pape plant, the ruffled opaline white shades housing electric bulbs, 26 in. high. **£1,250-1,500**

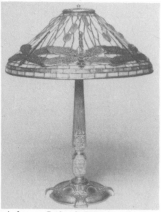

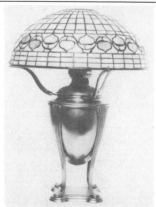

A dragonfly leaded glass and gilt bronze table lamp, by Tiffany Studios, with seven blue dragonflies with blue-green wings and pale blue 'Jewelled' eyes, impressed TIFFANY STUDIOS N.Y. 1495; the gilt bronze base in the 'Four Virtues' pattern, impressed TIFFANY STUDIOS NEW YORK 557, 25 in. high, 20 in. diam. of shade. **£4,000-6,000**

A Tiffany Studios bronze table lamp with a leaded glass shade, the shade with panels of green glass, 52 cm., inner unit stamped 'Tiffany Studios New York 29714', c. 1900. **£100-150**

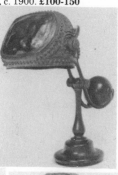

A turtle-back tile and bronze counter-balance desk lamp, the shade with iridescent green turtle-back tiles, impressed TIFFANY STUDIOS NEW YORK, 16 in. high. **£1,400-1,800**

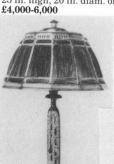

A Tiffany Studios gilt bronze, glass and abalone table lamp, 42.5 cm., stamped 'Tiffany Studios New York', 1910-20. **£440-540**

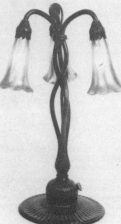

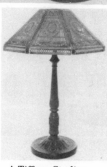

A Tiffany Studios bronze and glass desk lamp, the pierced faceted shade backed with milky blue glass, 46 cm., base stamped 'Tiffany Studios New York 539', c. 1900. **£500-600**

A Favrile glass and bronze three-light lily lamp, by Tiffany Studios, stamped TIFFANY STUDIOS NEW YORK 25873, 15½ in. high. **£1,000-1,250**

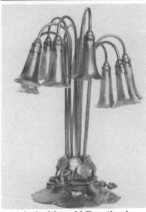

A 12-light lily gold Favrile glass
and bronze table lamp, by
Tiffany Studios, the shades
inscribed L. C. T. Favrile,
impressed TIFFANY STUDIOS
NEW YORK 382, 19 in. high,
one shade cracked and one with
chip to rim. **£3,500-4,000**

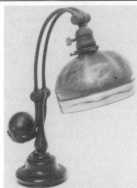

An intaglio-carved Favrile glass
and bronze desk lamp, by Tiffany
Studios, inscribed 2196G — L. C.
Tiffany-Favrile, the base
impressed TIFFANY STUDIOS
NEW YORK, 15¾ in. high, 7 in.
diam. of shade. **£1,500-1,750**

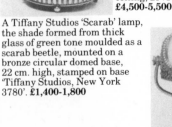

A green leaded glass and bronze
chandelier, by Tiffany Studios,
in the Chinoiserie manner, in
emerald green glass, the opaque
white glass bowl concealing six
light sockets, 46 in. height to
ceiling, 29½ in. diam. of shade.
£4,500-5,500

A Tiffany Studios 'Scarab' lamp,
the shade formed from thick
glass of green tone moulded as a
scarab beetle, mounted on a
bronze circular domed base,
22 cm. high, stamped on base
'Tiffany Studios, New York
3780'. **£1,400-1,800**

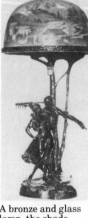

A turtle-back tile and gilt-bronze
desk lamp, by Tiffany Studios,
the shade with two white turtle-
back tiles, impressed TIFFANY
STUDIOS NEW YORK 9842,
17 in. high. **£1,750-2,000**

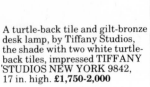

A bronze and glass
lamp, the shade
signed Arsoli, the
bronze signed Zach,
76 cm., fitted for
electricity, c. 1910.
£500-800

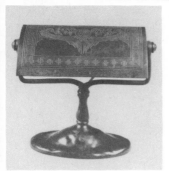

A Tiffany Studio bronze desk lamp, with overall greenish-brown patina, 23.5 cm. high, stamped 'Tiffany Studios, New York 642'. **£500-600**

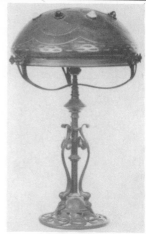

A bronze Art Nouveau lamp, 52 cm. high, c. 1900-10. **£360-420**

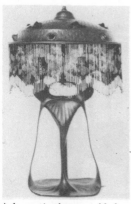

A decorative bronze table lamp, with beaten copper shade, 58 cm., c. 1900. **£400-460**

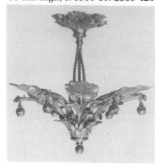

A gilt-bronze chandelier, French, c. 1915, impressed SOLEAU, 21 in. high. **£300-400**

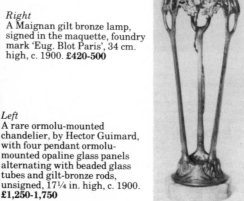

Right
A Maignan gilt bronze lamp, signed in the maquette, foundry mark 'Eug. Blot Paris', 34 cm. high, c. 1900. **£420-500**

Left
A rare ormolu-mounted chandelier, by Hector Guimard, with four pendant ormolu-mounted opaline glass panels alternating with beaded glass tubes and gilt-bronze rods, unsigned, 17¼ in. high, c. 1900. **£1,250-1,750**

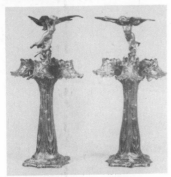

A pair of Art Nouveau gilt bronze lamps, by Raoul Larche, the stems veined and moulded with stylised foliage rising to four groups of leaves forming the lampshades, inscribed Raoul Larche and with fondeur's mark of Siot, 68 cm. high. **£1,200-£1,800**

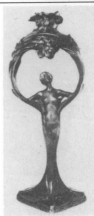

An Art Nouveau bronze lamp, 47.5 cm., c. 1900. **£1,200-1,500**

BRONZES

It is hardly surprising that an art suddenly set free of restraint should have produced images which were immediately labelled 'decadent'. For centuries, sculptors had striven to give substance to abstract themes representing man's higher endeavours and aspirations and, as such, had remained firmly in the 'fine art' tradition. The arrival of the new art caused many to re-examine their function — and many sculptors abandoned 'fine' for 'decorative' art, indulging themselves in the production of sensuous — and often erotic — figures. Dreamy-eyed and enigmatic models may have been, but their sculptural treatment generally suggests themes of which chastity is not a major ingredient.

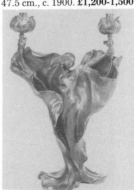

A bronze two-branch candelabrum, cast from a model by Marius Mars-Vallet, the unopened blossoms forming the two nozzles, rich medium brown patina, inscribed Mars-Vallet (wired for electricity), French, late 19th/early 20th C., 14⅛ in. high. **£750-1,250**

A bronze figure of a fish, cast from a model by Sarah Bernhardt, French, late 19th C., inscribed Sarah Bernhardt and impressed with the Hébrard foundry seal, 14½ in. high, including marble base, rich dark brown patina. **£4,000-6,000**

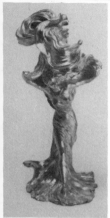

A pair of small German bronze Art Nouveau candlesticks, each in the form of a naked nymph, each stamped 'Geschch 5070', 21.5 cm., c. 1900. **£300-380**

A bronze table lamp, cast from a model by Firmin Bâte, dark brown patina, inscribed Bate, 43.4 cm. high. **£1,500-1,800**

An Art Nouveau gilt bronze figural lamp, 'Löie Fuller', cast from a model by Raoul Larche, c. 1900, inscribed Raoul Larche and impressed with circular foundry mark enclosing Siot-Decauville/Fondeur/Paris, rubbed, 13½ in. high. **£2,500-£3,500**

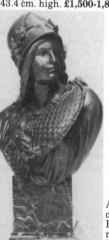

A gilt bronze figure of a nymph, cast from a model by Maurice Bouval, inscribed on a verdigris marble base, c. 1900, 15⅝ in. high. **£1,000-1,500**

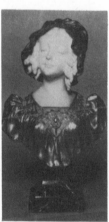

A bronze bust of Minerva, cast from a model by Albert-Ernest Carrier-Belleuse, inscribed A. Carrier-Belleuse and impressed with the Valsuani foundry seal, French, 20th C., 11¼ in. high, on veined green marble base, rich reddish brown patina. **£880-£1,000**

Carrier-Belleuse incorporated the bust of Minerva in his allegorical frieze for the facade of the Banque de France. The Banque had 20 casts of 'Minerva' made for the artist's family in return for permission to use the image on the one franc note.

A jewelled gilt bronze and marble bust of a young girl, French, late 19th C., signed A. Gory, 16¾ in. high, including veined black marble base. **£400-£600**

Condition of any article is of the utmost importance and must always be taken into account when negotiating the sale of any antique.

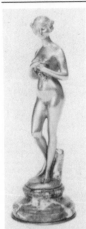

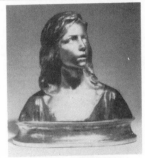

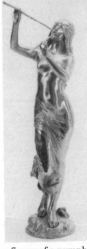

A bronze bust, on giltwood plinth, inscribed Raoul Larche, founder's seal Siot Décauville, Paris, serial no. 973K., 44.5 cm. high. **£1,100-1,300**

A gilt bronze figure of a smiling nymph, cast from a model by Jules Felix Coutan, inscribed COUTAN-Montorgueil on waisted pink marble base, French, early 20th C., 9 in. high. **£500-700**

A gilt bronze figure of a nymph playing pipes, cast from a model by Edouard Drouot, French, late 19th/early 20th C., inscribed E. Drouot, 26½ in. high. **£770-900**

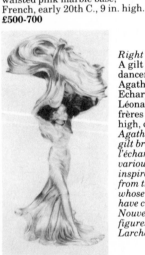

Right
A gilt bronze figure of a Grecian dancer, cast from a model by Agathon Léonard, from the Echarpe series, inscribed A. Léonard Sclp and M with Susse frères foundry stamp, 24¼ in. high, c. 1900. **£2,500-3,200**
Agathon Léonard is noted for his gilt bronze series, 'Le Jeu de l'écharpe', representing the various stages of dance. The inspiration for this series came from the dancer Löie Fuller whose movements were said to have characterised the Art Nouveau style. See also the figures of Löie Fuller by Raoul Larche.

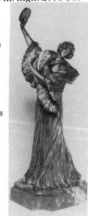

A gilt bronze figure of Löie Fuller, cast from a model by Raoul Larche, French, early 20th C., inscribed RAOUL LARCHE and impressed with the Siot-Décauville foundry seal, 17⅞ in. high. **£4,000-6,000**

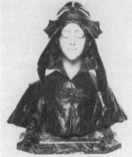

A Jacobs bronze and alabaster bust, on stepped octagonal green marble base, 42 cm., marked 'H. Jacobs', c. 1900. **£800-1,000**

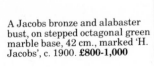

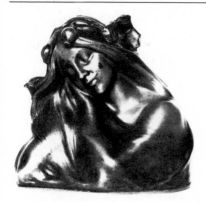

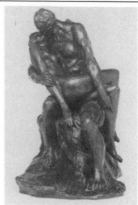

A small Muller bronze bust, signed in the maquette 'H. Muller', 12.5 cm., c. 1900. **£330-£400**

'The Kiss', a bronze group of two lovers, cast from a model by Alfredo Pina, Italian, late 19th/early 20th C., inscribed A. Pina, stamped twice FRANCE and impressed with an illegible foundry seal, 25⅝ in. high, dark greenish brown patina. **£1,000-£1,500**
The present example shows the influence of Pina's teacher Auguste Rodin.

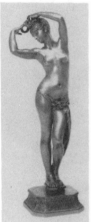

'Carthage', a parcel gilt bronze group of Salambo and Matho, cast from a model by Theodore Rivière, French, inscribed THEODORE RIVIERE, CARTHAGE, and Susse Fes Edts Paris, 17¼ in. high, including green marble base. **£1,500-2,500**
This sculpture was inspired by the play 'Carthage' with Sarah Bernhardt in the role of Salambo The model was exhibited at the Exposition Universelle of 1900 to great acclaim.

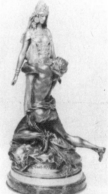

A gilt bronze figure of an Oriental dancer, cast from a model by Anthony Paul Noel, French, inscribed 'Tony Noel', stamped E487 and impressed with the Siot-Décauville foundry seal, 17¾ in. high, late 19th/early 20th C. **£1,000-1,500**

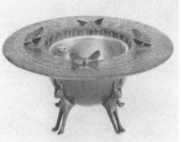

A bronze footed ashtray, by Armand-Albert Rateau, impressed A. A. RATEAU 1901 5396, 8 in. diam., with brass liner. **£1,750-2,250**

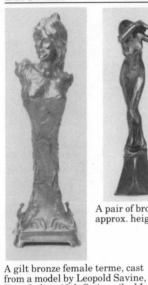

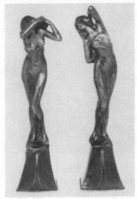

A pair of bronze figures, 20 cm. approx. height, c. 1900. **£280-360**

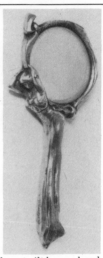

A gilt bronze female terme, cast from a model by Leopold Savine, French, late 19th C., inscribed L. SAVINE and stamped LOUCHET O, 15¼ in. high. **£900-1,100**

A small Clerget gilt bronze hand mirror, 15 cm., signed in the maquette, 'A. Clerget', c. 1900. **£280-360**

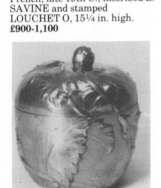

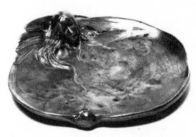

A Bouval bronze dish, 14 cm., marked 'M. Bouval' and with foundry mark 'E. Colin & Cie, Paris', c. 1900. **£125-175**

A gilt bronze covered bowl, cast from a model by Alexandra Vibert, French, inscribed A. Vibert, 6⅜ in. high, early 20th C. **£350-450**

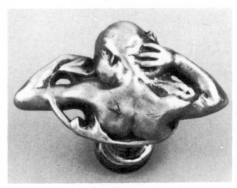

An unusual French bronze figural door handle, 5 cm. high, indistinctly stamped, possibly F.T. **£150-250**

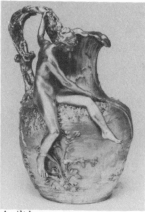

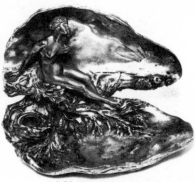

A Maillard silvered and gilt bronze ink stand, 21 cm., signed in the maquette 'Maillard', c. 1900. **£350-500**

A gilt bronze ewer, cast from a model by Alexandre Vibert, French, inscribed A. Vibert and impressed with the Siot-Décauville foundry seal and stamped G834, with copper liner, 16¼ in. high, traces of verdigris, early 20th C. **£900-£1,100**

A pair of gilt bronze surtouts de table, cast from models by Raoul-Francois Larche, wired for electricity, 11¼ in. high, French, late 19th C. **£1,800-2,400**

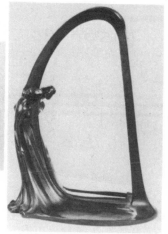

An Austrian bronze mirror, signed B. Butzke, 42.5 cm. high. **£1,100-1,300**

A Charpentier square bronze medallion, inscribed 'Société des Amis de la médaille Francais Fondée le 28 Février 1899'. **£90-£130**

An Art Nouveau bronze tray, probably by Raoul Larche, 50 cm. wide. **£650-800**

BRONZE

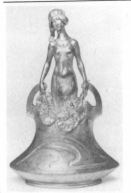

A gilt bronze vase, cast from a
model by Charles Korschann,
French, inscribed CH.
KORSCHANN PARIS, the
underside stamped LOUCHET,
17¼ in. high, early 20th C. **£900-
£1,200**

A bronze tazza, cast from a
model by Georges Engrand,
French, inscribed G. Engra
and impressed with the E. C
foundry seal with copper lin
8½ in. high, dark brown pa
early 20th C. **£400-600**

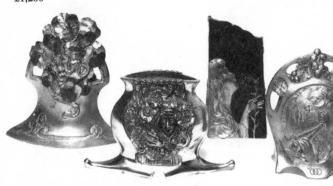

left to right

A small part gilt Korschann vase, 13.25 cm., marked 'Ch. Korschann Pa
founder's mark for Louchet, Paris, c. 1900. **£370-500**. A small Korschann
polished bronze vase, cast with the head of a young woman surrounded b

flowers, 9 cm., marked
Korschann', stamped
'Louchet', c. 1900. **£10**
A small De Lagrange
gilt bronze vase, 12 cm
marked 'De Lagrange
founder's mark for 'Lc
Paris', c. 1900. **£240-£**
small Korschann gilt
vase, 12 cm., marked
Korschann', founder's
'Louchet Paris', c. 190
£100-£175.

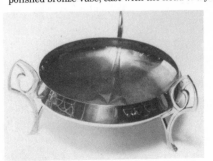

A W.M.F. silver Art Nouveau
fruit bowl, 10 in. diam. **£43-50**

SILVER

If there was any material in which English Art Nouveau craftsmen can be said to have achieved supremacy over those of other nationalities, it was silver. The emergence of the Arts and Crafts movement stimulated a vigorous revival of interest in all kinds of metalwork, but most notably silver and pewter, and the patronage of Arthur Lazenby Liberty ensured a good outlet for high quality work. Styles reflected the mood of romantic mediaevalism which was a major source of inspiration to British exponents of Art Nouveau and is best typified by Liberty's 'Cymric' range of silver goods.

The essential synthesis of material and form which represents one of the guiding principles of Art Nouveau is achieved as surely in the best of English silver of the period as it was by Gallé in glass. The use of strongly coloured enamels and semi-precious stones to enliven smooth areas of polished metal or emphasise sinuous line decoration served greatly to heighten the effect or restrained opulence, so important in silver-ware of tasteful distinction.

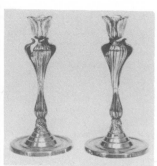

A pair of silver candlesticks, by Cardeilhac, Paris, stamped Cardeilhac and with French poincons, engraved underbase G.H.1900, 7¼ in. high, 17.5 troy oz., c. 1900. **£400-600**

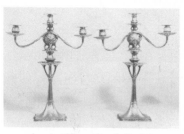

A pair of Ramsden & Carr three-light candelabra, with two twisted scroll branches issuing from a blue enamelled sphere overlaid with silver wave ornament, chased with a coat-of-arms and motto, maker's marks, 1905, 22½ in. high, gross weight of branches 104 oz. **£8,000-£12,000**

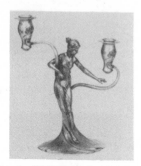

A pair of W.M.F. electroplated candlesticks, 24 cm., W.M.F. marks, c. 1900. **£900-1,300**

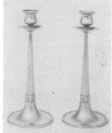

A pair of James Dixon & Sons silver candlesticks, the bases embellished with studs 23 cm. high, maker's marks and hallmarks for Sheffield, 1907. **£180-200**

71

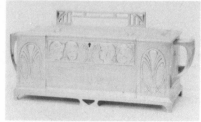

A silver-plated jewellery casket, by Württembergische Metallwarenfabrik, Austria, impressed with firm's hallmarks, 16¾ in. long. **£770-970**

A 'Cymric' enamelled silver covered presentation chalice, by Liberty and Company, London, with four brightly enamelled panels of Viking ships, stamped with firm's hallmark, 12¼ in. high, 58.5 oz., 1901. **£2,000-3,000**
Liberty and Company, founded by Arthur Lazenby Liberty in 1875, began their commercial production of silver in 1899. The old Celtic word 'Cymric' was chosen as a trade name for the silver as an acknowledgement of the influence of ancient Celtic illuminated manuscripts on the designs. The 'Cymric' range of silver was mass-produced by W. H. Haseler of Birmingham.

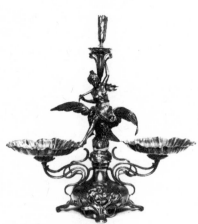

An electroplated metal centrepiece, 55.5 cm., c. 1900. **£200-300**

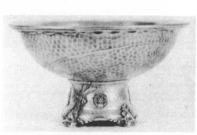

An applied silver centrepiece, by Tiffany & Co., c. 1890, the stem applied with a brass dragonfly, cicada, and beetle on a matching ground with openwork geometric and scroll medallions above four leaf form pad feet, impressed TIFFANY & CO. 6310 MAKERS 2345 925-1000, 1438 M, 8 in. high, 15¾ in. diam. **£1,200-1,500**

An enamelled silver cigarette case, by Fabergé, the obverse and reverse with openwork panel of orange irises on green stems in guilloche and cloisonne enamel, with cabochon-cut sapphire push-button, with hallmarks 4 in. long. **£1,250-£1,750**

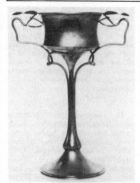

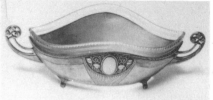

A W.M.F. silver Art Nouveau sweet dish, with glass lining, 11 in. long. **£55-65**

A William Hutton & Sons silver chalice, 31 cm., maker's marks, London, 1901. **£350-450**

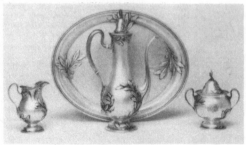

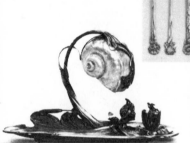

A set of twelve silver pastry forks, in the style of Bruckmann & Sohne, each depicting a spring flower; and a set of twelve spoons en suite, stamped, Gero 90, in retailer's fitted boxes, labelled Gero Zilvium. **£260-360**

An electroplated desk lamp/pen tray, with nautilus shell shade forming the lamp, fitted with an inkwell, 21.5 cm., c. 1900. **£660-£760**

A silver coffee service, by Tiffany & Co., decorated in repoussé, comprising: a coffee pot, creamer, sugar basin and cover, and a tray stamped with firm's marks and 16266-1208, 70 troy oz., c. 1900. **£1,000-1,500**

An Edward Barnard & Son Ltd. silver kettle, stand and spirit burner, maker's mark, London, 1911, 43 oz., 31.5 cm. high. **£680-£800**

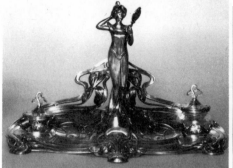

An Art Nouveau silver-plated double inkstand, probably German, housing two inkwells, 16 in. long. **£375-450**

A large silver-faced dressing-table mirror, by James Dixon & Son, surmounted by a coronet above two coats-of-arms, maker's mark, Sheffield, 1901, 69.8 cm. high. **£1,700-2,000**
The arms are those of Hamilton (dexter) and Howard (sinister) for Gladys Mary, Countess of Wicklow, of whose initials the monogram is comprised. Ralph Francis Howard, 7th Earl of Wicklow (1877-1946) married in 1902 Lady Gladys Mary Hamilton, younger daughter of 2nd Duke of Abercorn. The fact that the mirror was presumably intended for her dressing-table accounts for the odd circumstances of the arms of Hamilton appearing to dexter rather than sinister.

A W.M.F. electroplated mirror frame, 35 cm., W.M.F. marks, c. 1900. **£370-470**

An attractive Liberty & Co. silver-faced and enamelled picture frame, 19 by 15 cm., marked L & Co., 'Cymric' and hallmarks for Birmingham 1902. **£200-250**

A Hutton & Sons silver and enamelled picture frame, 20 cm., maker's marks for London 1903. **£300-400**

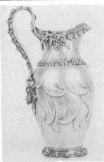

A silver pitcher, by Tiffany & Co., impressed TIFFANY & CO. 6540 MAKERS 7960 STERLING SILVER 925-1000 T, 10¼ pints, 15¼ in. high, c. 1900. **£500-750**

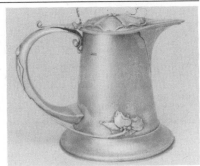

A silver covered pitcher, by William Hutton & Sons, England, stamped with repoussé poppies, with firm's hallmarks, 9¼ in. high. **£1,400-1,800**

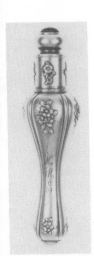

Two Liberty & Co. silver serving spoons, 20 cm., maker's mark, London, 1899. **£140-180**

An attractive Tiffany & Co. silver pomander, surmounted by almandine garnet cabochon, embossed and chased with bouquets of flowers, 12.5 cm., stamped Tiffany & Co., Sterling Silver Patd. Sept. 23 1890. **£300-£400**

A Liberty & Co. 'Cymric' silver and enamel spoon, the bowl cast with an entrelac and detailed in green and turquoise enamel, 15.75 cm., maker's mark, stamped 'Cymric', Birmingham, 1902. **£260-360**

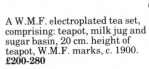

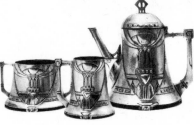

A W.M.F. electroplated tea set, comprising: teapot, milk jug and sugar basin, 20 cm. height of teapot, W.M.F. marks, c. 1900. **£200-280**

A pair of Art Nouveau silver-plated vases, by Victor Silver Co., each with impressed firm's mark and QUADRUPLE PLATE 1350, 8 in. high. **£280-£380**

A W.M.F. plated and glass vase, impressed marks, 50 cm. high. **£80-120**

PEWTER

Pewter is an alloy, consisting mainly of tin, which has been used in Britain since Roman times. When no lead is used in the alloy, pewter tends to remain bright and almost like silver; the higher the proportion of lead, the darker the colour.

Largely ousted during the nineteenth century, pewter was revived as a material by exponents of the Arts and Crafts movement, and their contemporaries and successors, followers of the Art Nouveau.

In Britain and Germany particularly, Art Nouveau pewter work achieved great popularity and high standards of craftsmanship. Liberty's 'Tudric' range of pewterwares, decorated with motifs taken from the Celtic, included tea and coffee services as well as clocks, tableware, bowls and vases. The chief German exponent was Engelbert Kayser (1840-1911), whose range was as extensive as Liberty's, but fashioned in the 'high' Art Nouveau style.

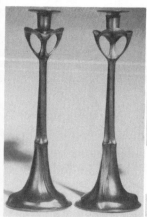

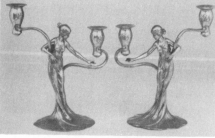

A pair of W.M.F. pewter and brass two-branch candelabra, stamped marks, 26.5 cm. high. **£850-950**

A pair of Kayserzinn pewter candlesticks, probably designed by Hugo Leven, oval stamped mark, Kayserzinn 4427, 42 cm. high. **£1,200-1,800**

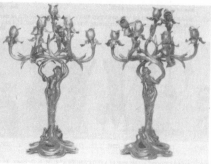

A pair of Art Nouveau pewter candelabra, possibly by A. Perren, the standing young maiden supporting seven bud shaped branches, one branch broken, 20 in. high. **£200-300**

A pair of Liberty's 'Tudric' pewter Art Nouveau bon bon dishes, 1912, 5½ in. high. **£85-£110**
Tudric is the trade name for mass-produced pewter ware produced by Liberty & Co.

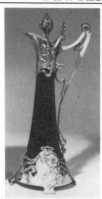

A W.M.F. green glass and pewter claret jug, stamped marks, 40.5 cm. high. **£400-500**

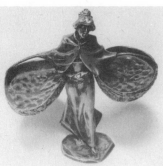

An Art Nouveau pewter sweetmeat centrepiece, 8½ in. long. **£200-215**

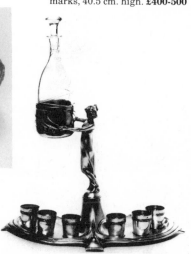

A W.M.F. pewter liqueur set, 37 cm., WMF marks, c. 1900. **£175-225**

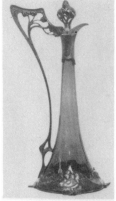

A W.M.F. pewter-mounted green glass decanter and stopper, pierced openwork stopper, 38.75 cm., WMF marks, c. 1900. **£450-550**

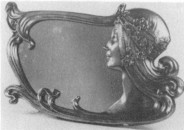

An Art Nouveau pewter-framed mirror, cast from a model by Charles Jonchery, inscribed C. Jonchery, 72 cm. wide. **£500-700**

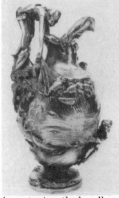

A pewter jug, the handle modelled in full relief as a young girl dragging a net from the sea, the spout cast with a mask of Neptune, 32.5 cm., c. 1900. **£250-£350**

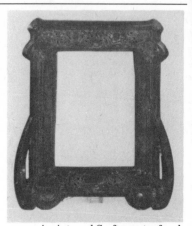

An Arts and Crafts pewter faced picture frame, by the March brothers, 26 cm. high. **£75-150**

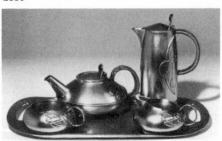

A Liberty & Co. Tudric pewter tea service, designed by Archibald Knox, embossed with an entrelac honesty design, comprising: a teapot, a hot water jug, a milk jug, a sugar bowl and a shaped rectangular tray, all with stamped marks for English or Tudric pewter 0231, two pieces stamped Liberty & Co., width of tray 46 cm. **£400-600**
Archibald Knox, along with Rex Silver, was Liberty's main designer of pewter and silver. Knox, who came from the Isle of Man, produced over 400 designs for the Regent Street firm.

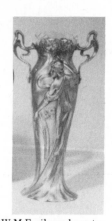

A pair of W.M.F. silvered-pewter vases with clear glass liners, base 36.5 cm. high. **£660-800**

A 'Tudric' pewter tea and coffee service, by Archibald Knox for Liberty & Co., comprising: a teapot, creamer, sugar bowl, hot water jug and tray, three pieces with rattan handles, each stamped with firm's marks and numbering, 19 in. diam. of tray. **£600-800**

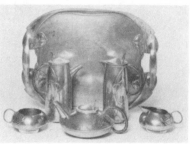

Make the most of Millers...

Remember that this book is a price *guide,* not a price *list.* Valuations given throughout apply to the specific prices shown and, though they may reasonably be taken as a guide to the values of other similar articles, other factors may also apply.

Condition of any article is of the utmost importance and must always be taken into account when negotiating the sale of any antique.

A Liberty & Co. pewter clock, designed by Archibald Knox, face richly enamelled in deep blue and green with red detailed motif at the centre, 20.25 cm., stamped 'Rd. 468016 0609, English Pewter Made by Liberty & Co.', c. 1905. **£850-1,100**

Right
An Art Nouveau metal clock, designed by Jules Brateau, with a blue enamelled face with gilt numerals, inscribed on the panels Jules Brateau, 35 cm. high. **£1,050-1,200**

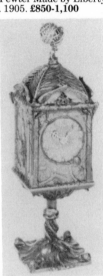

An Art Nouveau table clock, by A. L. S. Daguet, clad in copper and set with glass 'jewel' cabochons in various colours, signed and dated, 1902, 16¼ in. high. **£1,000-1,250**

A Doré bronze three piece clock garniture set, French, after De Feure, the openwork floral rectangular case set with enamel dial, with a pair of five light candelabrum, 18 in. high. **£500-750**

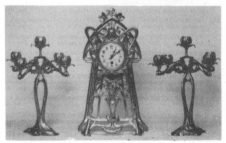

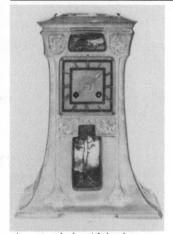

A Liberty & Co. pewter and enamelled clock, designed by Archibald Knox, the mottled blue and green circular dial with a central red enamelled berry motif within copper numerals, stamped English Pewter 0609, Rd. 468016, 20.5 cm. high. **£750-£950**

A pewter clock, with landscape enamelled plaques on the case, with copper dial, incised on reverse 'March Bros., 1905', 33.50 cm. high. **£300-400**

A Liberty & Co. 'Cymric' silver timepiece, set with two turquoise matrix cabochons, the dial with legend 'Festina Lente', 10 cm. high, maker's marks for Birmingham 1905. **£200-250**

A Liberty & Co. 'Tudric pewter and enamel clock, rich blue/green enamelled circular face, with entrelac below, detailed in blue peacock and red enamel, 18 cm., stamped 'Tudric 0629', c. 1905. **£260-360**

A Liberty & Co. 'Tudric' pewter clock, designed by Archibald Knox, 14 cm., stamped 'Made in England Tudric Pewter 0106, Rd. 468015', c. 1903. **£580-650**

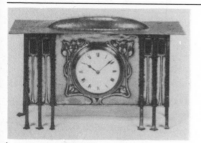

A copper cased Art Nouveau timepiece, the design attributed to George Walton, 21 cm. high. **£200-300**

A Liberty & Co. 'English Pewter' timepiece, the circular face enamelled blue/green, 21 cm. high, stamped marks and numbered 0761. **£150-250**

A Liberty & Co. 'Cymric' silver and enamel clock, maker's mark, stamped 'Cymric' Birmingham 1904. **£550-650**

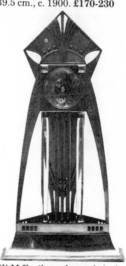

A W.M.F. silvered metal clock, with a thermometer set in the openwork body, WMF marks, 39.5 cm., c. 1900. **£170-230**

A W.M.F. silvered metal clock, with three central cylindrical supports flanked by faceted glass columns, 45 cm., WMF marks, c. 1910. **£260-360**

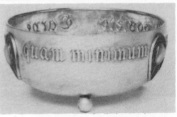

An attractive Art Nouveau bowl, embossed with a legend in Latin and set with green enamelled medallions centred with mother of pearl and wirework, 21 cm. diam., silver coloured metal unmarked. **£200-400**
Possibly an early example of the work of George Jensen of Denmark, who created a style of silver ware which has survived until the present day.

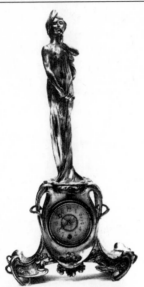

A silvered pewter Art Nouveau clock, surmounted with the figure of a young woman, 62.5 cm., underside stamped 'B C Imperial 4883', c. 1900. **£200-300**

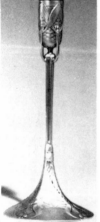

A pair of French silvered-metal candlesticks, designed by Emile Gallé, impressed AF, 24.5 cm. high. **£700-900**

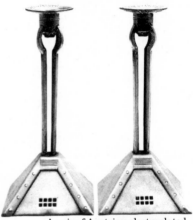

A pair of Austrian electroplated metal candlesticks, 18.25 cm., c. 1905. **£60-100**

A brass Carnet de Bal, by Wiener Werkstätte and attributed to Joseph Hoffman, inscribed 'Concordia Ball 1909', bound in red leather, signed Wiener Werkstätte, 5⅝ in. long. **£900-1,200**

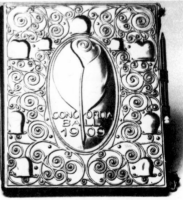

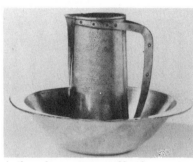

A Jouant patinated metal dish, cast in low relief with a nymph riding a seahorse, marked 'Jouant', 68 cm. wide, c. 1900. **£120-160**

MACKINTOSH, Charles Rennie (1868-1928)

Although he is popularly known as the designer of rather austere, angular furniture, Mackintosh was first and foremost an architect. He was responsible for a number of individual furniture designs, but the most important aspects of his work were concerned with what might nowadays be termed as 'total environment' design; he believed that the work of an architect should not end with the building, but should be extended to include all furniture and fittings, from light switches to cutlery. During his lifetime, his work was little appreciated in Britain, though it had considerable impact in Austria and Germany.

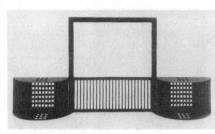

A silvered copper ewer and bowl, c. 1904, ewer 28 cm. high, bowl 39.8 cm. wide. **£2,000-3,000**

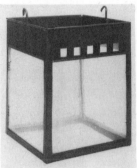

A metal and opalescent glass hanging light fitting, designed by Charles Rennie Mackintosh for the Hall at Windyhill, Kilmacolm, four panels of eau-de-nil opalescent glass slotted into stained metal framework, 25.25 cm. high by 21 cm. wide and long, 1901. **£1,200-1,500**

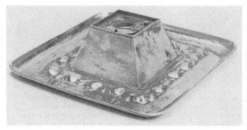

An iron firefront designed by Charles Rennie Mackintosh, 70 cm. high, by 152.5 cm. wide, 1904. **£6,000-9,000**

A Newlyn silver and enamelled square inkstand, inset with a green enamelled circular medallion, applied with a plaque inscribed W.H.H. and G.E.H., impressed RTD, Newlyn marks, London, 1911, 24 cm. square, 22.50 oz. **£250-350** *Reputed to have been made for Sir William Henry Hadow, the educationalist and author of the Hadow Report.*

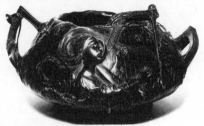

An Aurili patinated metal
jardiniere, 44 cm. max. width,
signed 'R. Aurili', c. 1900. **£120-
£150**

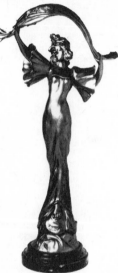

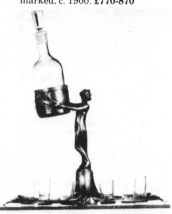

A German silvered-pewter Art
Nouveau lamp, with Nautilus
shell shade, 36.5 cm., indistinctly
marked. c. 1900. **£770-870**

'Stella', a Nelson gold painted-
metal Art Nouveau lamp,
marked 'Ant Nelson' applied
title plaque, c. 1900, 67 cm.
£280-330

A W.M.F. silvered metal liqueur
holder, the batwing-shaped base
containing six liqueur glasses,
the centre with a young woman
holding a cylindrical container
with a liqueur bottle, 9 in. high,
stamped marks. **£125-175**

An Art Nouveau W.M.F. trinket
box from the Gaiety Theatre,
presented to Frances Fowler,
5 in. long. **£30-40**

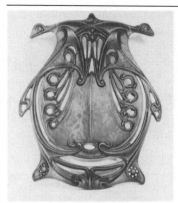

A rare cast-iron medallion from
the Paris Metro, designed by
Hector Guimard, c. 1898,
29½ in. high, black patina.
£1,000-1,200
*Note the characteristic Guimard
whiplash and foliate motifs.*

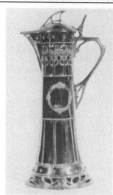

A brass mounted copper pitcher,
probably German, c. 1900, the
copper body with a band of
repoussé fruit-laden plants
above an openwork brass foot,
impressed 106, 15½ in. high.
£75-100

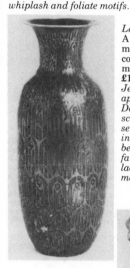

Left
A Jean Dunand wrought-
metal vase, inlaid in
contrasting metals, 17 cm.,
marked 'Jean Dunand 1913'.
£170-220
*Jean Dunand served an
apprenticeship with Jean
Dampt, the mixed media
sculptor; he produced a
series of Art Nouveau vases
in various metals prior to
becoming internationally
famous in the 1920's as a
lacquer and non-precious
metals worker.*

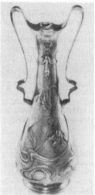

A Hannig silvered metal vase,
marked 'J. R. Hannig', 46 cm.,
c. 1900. **£150-200**

A Henri Fugère
patinated metal
figural vase,
embellished in relief
with bronzed and
gilded nymphs,
56 cm. high,
inscribed H. Fugère.
£200-300

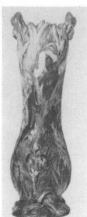

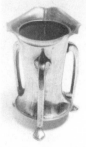

An Art Nouveau brass and
copper vase, by Fisher Strand,
6 in. high. **£15-20**

JEWELLERY

The fluid stylisation of form which characterises the Art Nouveau movement lends itself admirably to jewellery design, as does the preoccupation of artists of the period with flowers and insects.

Broadly speaking, Art Nouveau jewellery falls into one of two categories; the very highly priced, 'decadent' pieces which were individually designed for the wealthiest leaders of Parisian fashion, and the more modest, sometimes mass-produced, accessories which found greater favour with the British market. Particularly attractive to today's buyers are the silver and bright enamel pieces which were included in Liberty's range.

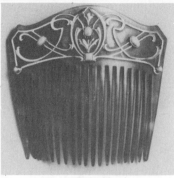

A Liberty & Co. blond-tortoiseshell and gold hair ornament, set with six turquoise matrix, impressed L & Co. marks, 10 cm. wide. **£250-350**

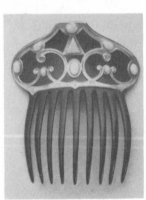

An Art Nouveau tortoiseshell, opal and gold comb, applied with gold scrolls and studded with oval and a triangular cut white opal, unmarked. **£330-430**

A Lacloche Frères hair comb, decorated with entwined whiplash stems studded with brilliants and marcasites, 11 cm., marked 'Lacloche Fres Paris', c. 1900. **£250-350**

An Art Nouveau horn hair comb, mounted with a gold looping trailing band. **£60-80**

An Art Nouveau hair comb, mounted with a band of hammered silver, enamelled with raised green leaves and a central red and yellow boss. **£100-150**

A gold hair comb ornament, the pierced whiplash design set with four turquoises, 11 cm., maker's mark 'B.H.J.', stamped 9 ct., c. 1900. **£150-200**

An Art Nouveau hair comb, mounted with gold banded circles centred with cabochon amethyst-coloured stones. **£60-£100**

A German Art Nouveau buckle, 6.5 cm., silver coloured metal. **£170-230**

A William Comyns silver Art Nouveau buckle, 9 cm., stamped Rd. No. 352369, maker's mark, London, 1902. **£60-100**

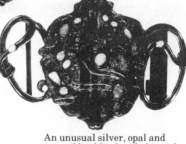

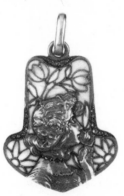

An unusual silver, opal and enamel buckle, detailed in rich pink/turquoise and yellow/green enamels and set with irregular cabochon opals, 13.5 cm., c. 1900, in fitted box. **£80-120**

A gold and plique-à-jour pendant, embellished with the profile head and shoulders of a Mucha-style girl against a coloured translucent enamel ground, set with rose cut diamonds, 3.5 cm. **£900-1,200**

An Art Nouveau pendant, 3.5 cm., silver coloured metal, the link stamped '900', probably Austrian. **£180-220**

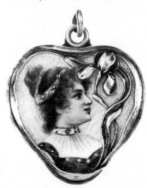

An Art Nouveau horn buckle, by
Lucien Gaillard of openwork
wing shape and carved with
holly leaves and an applied bee,
signed. **£1,100-1,300**

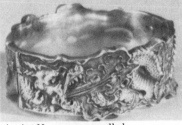

An attractive Lalique gold and
enamel Symbolist pendant,
decorated with a thin layer of
translucent pink opalescent
enamel, 4 cm., marked 'Lalique',
c. 1900. **£2,600-3,000**

An Art Nouveau enamelled
silver bracelet, the silver with
two dragons breathing fire
amongst enamelled blue clouds,
7 cm. wide, the clasp stamped
Lalique. **£2,500-3,000**

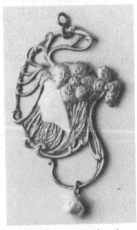

An oval Art Nouveau silver
pendant, by Lucien Gaillard,
opening to reveal a mirror,
signed L. G. Déposé. **£550-750**

An early silver, enamel and
baroque pearl pendant, formed
as the profile of a girl with blue
flowers in her flowing tresses
suspending the pearl, 10 cm.
high, impressed R. Lalique.
£900-1,100
*This pendant appears to be the
prototype for a larger model
made in 1895.*

A silver, pearl and plique-à-jour
enamel choker, probably French,
the panels in powder blue plique-
à-jour enamel with seed pearls
and freshwater pearls, three
matching smaller panels joined
by silver chains, 11¾ in. long,
c. 1900. **£2,250-3,000**

CHERET, Jules
(1836-1930)

Already in his fifties by the time the Art Nouveau movement got under way, Chéret is considered by some commentators to have rather missed the point — though his posters and his name are generally associated with the movement.

'Sarah Bernhardt' by Paul Berthon, lithograph printed in colours, 1901, very slightly timestained, tiny nicks at the edges, taped to the mount in two places at the upper edge, but generally in good condition, framed, 507 by 361 mm. **£400-£600**

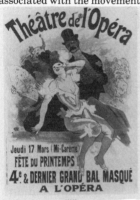

'Théâtre de l'Opéra' by Jules Chéret, lithograph printed in colours, 1897, very slightly stained, laid on thin Japan, linen-backed, 1210 by 810 mm. **£500-700**

'La Dépêche, Toulouse' by Foäche, lithograph printed in colours, before 1897, an extremely rare print, with the address of Cassan Fils, Toulouse, & Paris, two vertical creases with some splits, a central horizontal repaired split, a repaired tear upper left, other lesser surface defects, tiny nicks at the extreme edges, slightly stained, linen-backed, framed, 626 by 1365 mm. **£1,500-2,500**
Published as a poster for the newspaper of the same name.

'Retour' by Georges de Feure, L'Estampe Moderne series, with publishers' blindstamp, good condition, 14¼ by 10 in., 1897. **£150-250**

'Musée Grévin', Théâtre les Fantoches de John Hewell' by Jules Chéret, lithograph printed in colours, 1900, with the address of Chaix, minor defects, linen-backed, framed, 1190 by 832 mm. **£600-800**

'Lithographies Originales' by Georges de Feure, lithograph printed in colours, c. 1898, published and printed by E. Duchatel for Lemercier, with small margins, a pinhole at the right, a few surface defects, very slightly stained, laid on board, framed, 600 by 447 mm. **£800-£1,200**

MUCHA, Alphonso Maria (1869-1939)

Mucha was born in a small town in Czechoslovakia, and the healthy, coquettish buxomness of the girls he drew for many of his posters and lithographs testify to the fact that, despite living the life of an ultra-sophisticate in fin de siècle Paris, he never forgot his rural background.

Although he is best known for his posters, which have been widely reproduced in recent years, Mucha's talents extended to sculpture, and the design of shop interiors, stage sets, furniture, costumes, jewellery and ceramics.

'Absinthe Robette' by Privat Livemont, lithograph printed in colours, 1896, with the address of J. L. Goffart, Brussels, some soft creasing, two holes at the left edge, some nicks at the right edge, taped to the mount at the extreme edges, framed, 1055 by 755 mm. **£500-700**

'Zdenka Cerny', by Alphonse Mucha, a good fresh impression, some creasing in area of cello, 40 by 41 in., 1913. **£700-900**

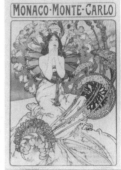

'Monaco Monte Carlo' by Alphonse Mucha, lithographic poster printed in fresh colours including silver, 105 by 70 cm., imp. F. Champenois, Paris, signed in block Mucha, and dated 1897, framed and glazed. **£2,500-3,500**

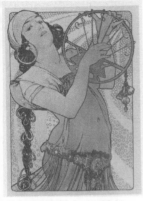

'Salome' by Alphonse Marie Mucha, lithograph in colours, 1897, published in L'Estampe Moderne, Numero 2, Juin, 1897, with the blindstamp (L.1790) with margins, very slightly timestained, some foxing and a crease in the margins, a little soiling in the margins and on the reverse, old tape, framed, 13¼ by 9¼ in. **£325-375**

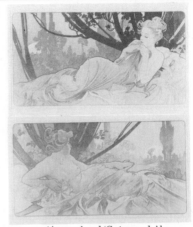

'Aurore' and 'Crépuscule' by Alphonse Mucha, a pair of lithographic paneaux printed in fresh colours, each 46 by 88 cm., imp. F. Champenois, signed in block Mucha, and dated '99, framed and glazed. **£3,000-3,500**

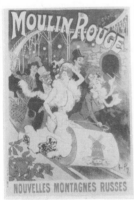

'Moulin Rouge', 1901, by Réné Pean, a lithograph in colours, signed in the block, 47 by 32½ in., framed. **£250-350**

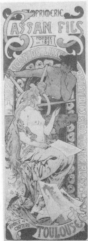

'Imprimerie Cassan Fils' by Alphonse Mucha, lithograph printed in colours, 1897, on two sheets, with the address of Cassan Fils, Toulouse, with four tears at the upper edge, a central repaired loss, some losses and small tears at the extreme edges where folded, light stained, framed, 1700 by 645 mm. **£1,000-£1,500**

'La Femme au Paon' by Louis John Rhead, lithograph in colours, 1897, published in L'Estampe Moderne, Numéro 3, Juillet 1897, and with the blindstamp (L.2790) some faint timestaining at the edges, old hinges, 13⅜ by 8⅞ in. **£125-150**

INDEX